IMAGES
of America

CAPE COD
FIREFIGHTING

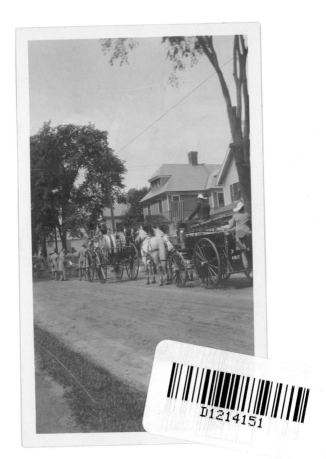

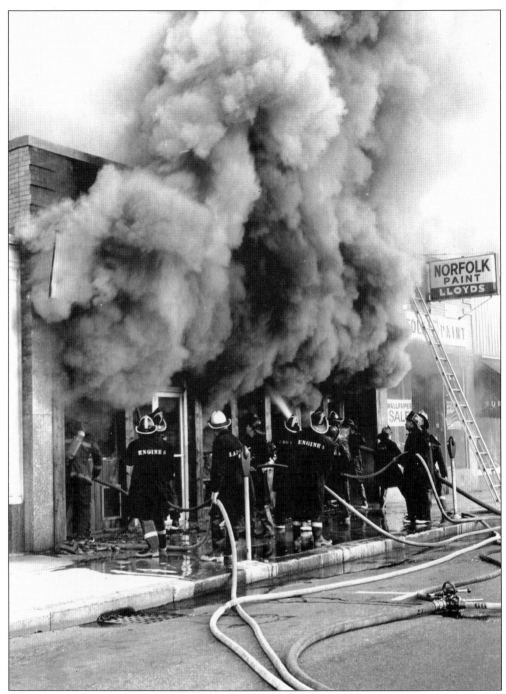

MAIN STREET, HYANNIS. The battle to contain and extinguish this fire at a business called This is the Place, at 384 Main Street in Hyannis, began at 7:10 a.m. on November 5, 1966. The dark smoke is evidence of a serious, deep-seated fire. Gaining access through locked doors, preventing the fire from extending to neighboring stores, and making entry without sufficient airpacks made fires like this difficult to fight. Two alarms were struck, bringing mutual aid in to help Hyannis firefighters. (Hyannis Fire Department collection.)

IMAGES
of America

CAPE COD
FIREFIGHTING

Britton W. Crosby

ARCADIA
PUBLISHING

Published by Arcadia Publishing
Charleston SC, Chicago IL, Portsmouth NH, San Francisco CA

Printed in the United States of America

Library of Congress Catalog Card Number: 2003101268

For all general information contact Arcadia Publishing at:
Telephone 843-853-2070
Fax 843-853-0044
E-mail sales@arcadiapublishing.com
For customer service and orders:
Toll-Free 1-888-313-2665

Visit us on the Internet at www.arcadiapublishing.com

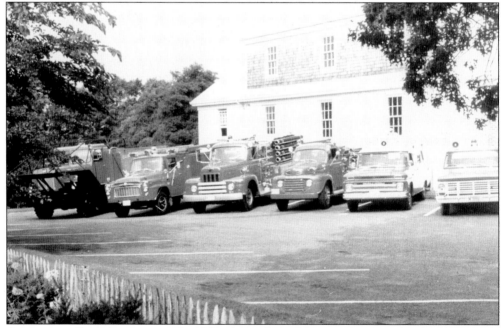

OSTERVILLE FIRE APPARATUS. In 1968, the author's hometown station (Radio KCD 760), in Osterville, was home to all this apparatus—216 was the big 1967 brush breaker; 302, the 1960 rescue squad truck; 309, the 1963 Engine 4; 307, the old 1950 Ford Engine 1; 303, the 1966 ambulance; and 210, the town patrol truck. (Centerville-Osterville-Marstons Mills Fire Department collection.)

CONTENTS

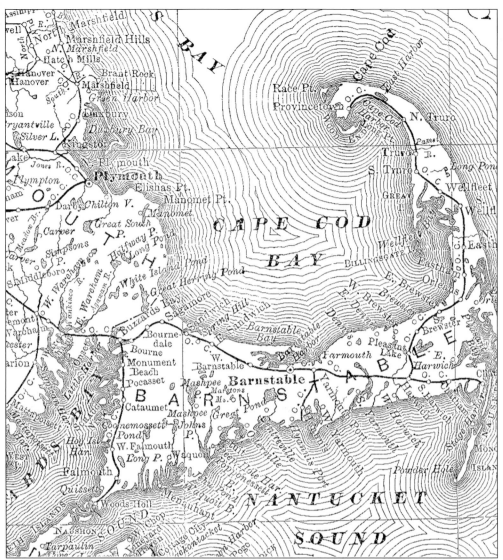

CAPE COD, MASSACHUSETTS. Barnstable County includes the towns of Barnstable, Bourne, Brewster, Chatham, Dennis, Eastham, Falmouth, Harwich, Mashpee, Orleans, Provincetown, Sandwich, Truro, Wellfleet, and Yarmouth. Of these 15 towns, 14 have town fire departments. The town of Barnstable has five independent fire districts (Barnstable, Centerville-Osterville-Marstons Mills, Cotuit, Hyannis, and West Barnstable). Other departments on the Cape include the Otis Fire Department and the state forest fire department.

INTRODUCTION

My interest in Cape Cod's fire departments began in the early 1970s, when I would visit my cousin Gus Crosby at the Osterville fire station. "Uncle Gus" was one of the first permanent firefighters in the village, and his commitment and love for the job was inspirational. He served as my mentor, and I dedicate this book to him. I am forever grateful for his teaching, guidance, friendship, and example over the years. It led to a wonderful career full of excitement and rewards.

In its early days, Cape Cod was a very rural area with large tracts of forests, pastures, and farmland. Small villages developed around crossroads, and along the bays and harbors that surround the Cape. Most residents made a living off the sea in one way or another. The winters could be long. Summers welcomed tourists and "summer people" from off-Cape. Roads were not great, and highways were nonexistent. The train came to the Cape and, by 1873, went all the way to Provincetown.

Although fires were not frequent, they were devastating when they did occur. Many large hotels, churches, stores, and homes were destroyed, with little firefighting personnel or equipment available. Church bells would ring, and efforts of townspeople were focused on removing valuables and trying to keep the fire from spreading to other buildings. By far, the largest fires were those that routinely ravaged forests during the spring. Thousands of acres were blackened each year, producing huge amounts of choking smoke and threatening to destroy buildings and valuable woodlands.

Fire departments on Cape Cod developed independently to meet the needs of their communities. Provincetown's volunteer fire department was the first, organizing in the early 1800s. The department used hand tubs, a horse-drawn steam engine, and a variety of other "macheens" over the years to protect its congested seaside community. Each of the Cape departments has its own unique and special history to tell.

There is also a great collective history, as these departments have worked together, supporting each other, with a common radio system, mutual-aid system, and emergency medical services system. The growth of the Cape and its fire departments has been dramatic over the years. These fire and rescue departments have met challenges and earned respected reputations. All the people who have served as call and permanent firefighters, EMTs, paramedics, and officers deserve to be recognized for their various contributions, commitment, and service to these communities and to the people of Cape Cod.

When I was approached to work on this book, I was immediately intrigued by the possibilities. The journey began in earnest to gather the information and photographs necessary to produce a book. As I visited various departments and individuals, looking through dusty old photo albums, scrapbooks, and documents, I began to realize how special this project was. At times, I was completely humbled by the openness and trust of these departments as I was literally invited in to look at their "family" history and pictures. I am honored to be able to share some of this history, and these photographs, in this book. I hope you enjoy it and the history it represents.

ACKNOWLEDGMENTS

This book would not have happened if it were not for the efforts of my partners in this project: David Rodriguez (Dennis fire captain), Chris Guerreiro (Dennis firefighter), and Joan Frederici (director of the New England Fire and History Museum in Brewster). I appreciate everything they did to help this book happen.

I would like to thank the chiefs and members of each of the Cape departments for their openness, support, and use of department images. There are many individuals I wish to thank specifically for their help and contributions: Chief Mike Trovato, Warren Alexander, Adam Wolf, Joyce, John W. Garran Sr., Lorne Russell, Chief Alan Hight, Richmond Bell, Chief Glen Olsen, Barry Bartolini, Bill Quinn, Dick Hunter, Chief Robert Peterson, David Leblanc, Chief Roy Jones, Chief Paul Tucker, Rob Christenson, Chief Harold Brunelle, former Chief Glenn B. Clough, Dean Melanson, Jack Grant, John McHugh, Robert Crosby, Chief John Jenkins, Bob Crocker, Chief John Farrington, John Monroe, Peter Thomas, Gordon Caldwell, Harold Cobb, David Still, Walter "Spike" Dottridge, Gordon Peters, Glen Rogers, former Chief Calvin Hitchcock, Chief Dennis Newman, David Boles, former Chief Fizzy Crowell, William "Sparky" Donovan, Nezka Pfeifer, Barbara Gill, Chief Charles Klueber, former Chief Steven Philbrick, Stuart Small, Don Jacobs, and Howie Smith. Some of the photographers of images in various collections were not known, but their work is appreciated.

Historical information was derived from a variety of sources: the *Advocate*, the *Cape Cod Times*, the *Cape Cod Standard Times*, the *Barnstable Patriot*, the Bourne Archives, the Sandwich Archives, the Sandwich Glass Museum, Wellfleet Town Hall, and Provincetown Town Hall. The following books were also used for reference: *Hunneman's Amazing Fire Engines*, by Edward R. Tufts; *Those Magnificent Old Steam Fire Engines*, by W. Fred Conway; *Chemical Fire Engines*, by W. Fred Conway; *Buffalo Fire Appliance Corp.*, by Peter D. West; *The History of the Orleans Fire Department*, by Herb Fuller Sr.; and *Spritsail*, by the Woods Hole Historical Society.

A project like this does not happen without the cooperation and understanding of family members. I thank my wife, Robyn; my daughter, Ashley; and my son, Alexander, for putting up with me as I took time from them to work on this book. I love you. You are the best.

One

IN THE BEGINNING

CAPE COD'S FIRST FIRE DEPARTMENT. Provincetown organized the first fire department on Cape Cod in March 1836. The congested waterfront community at the Cape's tip has always been protected by a volunteer fire department. Using hand tubs, horse-drawn apparatus, a steam engine, and motorized chemical engines and pumpers, the men and women of Provincetown's fire department have saved their town from conflagrations many times. (Crosby photograph, Provincetown Fire Department.)

PROVINCETOWN ARTIFACTS. Thirty used leather buckets, 100 feet of hose, and other necessary fixtures were purchased in November 1836. Buckets were used in bucket brigades to fight the fire and fill the tub of the fire engine *George Washington*. The speaking trumpet was used to shout commands to firemen fighting the fire. These historical artifacts and the *George Washington* are on display at the Provincetown Museum at the Pilgrim Monument. (Crosby photograph.)

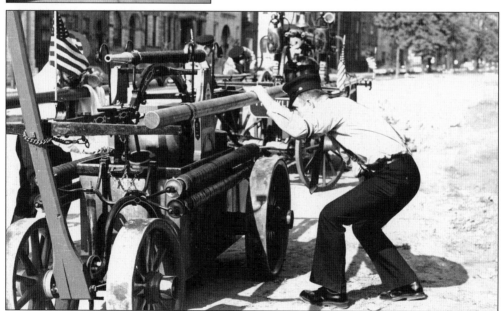

GEORGE WASHINGTON NO. 1. George Washington, Provincetown's handmade hand-drawn Hunneman fire engine, was the first engine on Cape Cod. Delivered on August 20, 1836, it was built in Boston and is easily recognized by its wide sand wheels, made expressly for Provincetown. It had a five-inch end-stroke engine and reversible handles, popular in New England villages with narrow passageways. The engine is shown at a parade in Baltimore in 1973. (Provincetown Fire Department collection.)

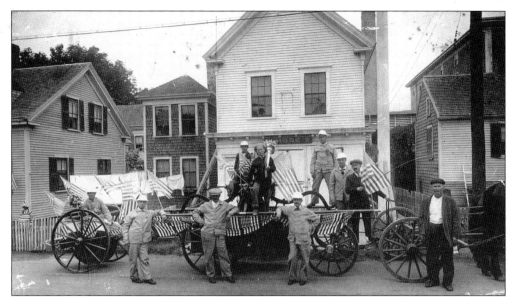

FRANKLIN NO. 2. Another Hunneman hand tub engine, named *Franklin No. 2*, was delivered to Provincetown in June 1850. In 1871, Hunneman delivered a new *Franklin No. 2*. This photograph, taken on July 4, 1916, shows patriotic firemen with their 1871 apparatus in front of the west end firehouse (117 Commercial Street at Franklin Street). Drawn by borrowed horses, it also towed a hose cart called a jumper, which carried 500 feet of 2¹/₂-inch hose. (Provincetown Fire Department collection.)

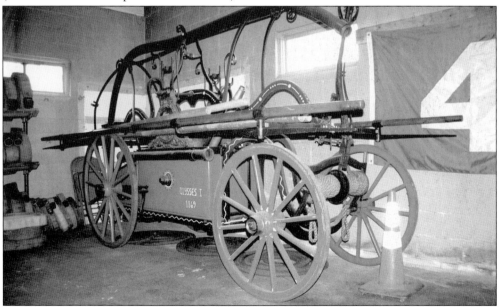

ULYSSES NO. 1. This engine was housed in the east end station (514 Commercial Street). Provincetown operated at least six Hunneman engines between 1836 and the 1920s: *Washington No. 1* (1836), *Franklin No. 2* (1850), *Mazeppa No. 3* (1868), *Excelsior No. 4* (1868), *Ulysses No. 1* (1869), and the second *Franklin No. 2* (1871). *Mazeppa* and *Excelsior* were 1854 Hunnemans bought secondhand in 1868. The first *Franklin* was in relief status when it was activated as *Tiger No. 5* (1873). (Crosby photograph, Provincetown Fire Department.)

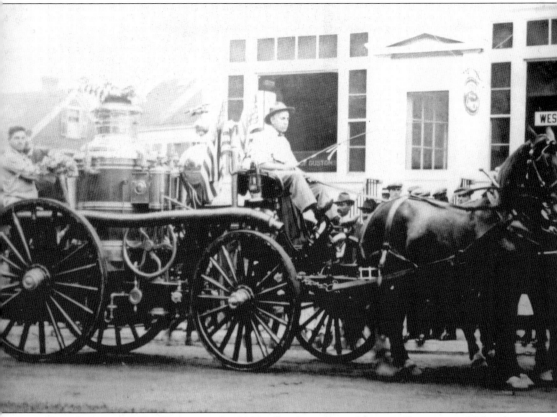

THE STEAMER *J.D. HILLIARD*. In 1889, the Amoskeag Steamer Company of Manchester, New Hampshire, delivered the only known steam fire engine to serve on Cape Cod. The size-3 steamer could pump 550 gallons per minute, weighed 6,000 pounds, and was 24 feet long and 8 feet 10 inches tall. Named for the fire chief at the time, John D. Hilliard (1872–1897), it was operated by the men of Steamer No. 3 until motorized apparatus came in the 1920s. At 1:55 a.m. on March 14, 1908, lightning struck the 200-foot steeple of the Centenary Church (at Commercial and Winthrop Streets). *J.D. Hilliard* pumped from a cistern at Court Street, as hand pumps, hose companies, and Rescue Hook and Ladder Company No. 1 fought to save the church. At 3:00, the steeple crashed to the ground in a mass of flames, nearly killing half a dozen firemen. By 5:00, the church lay in ruins, but the surrounding dwellings, one not more than 20 feet away, sustained only blistered paint and charred shingles thanks to the work of firefighters and this steamer. (Provincetown Fire Department collection.)

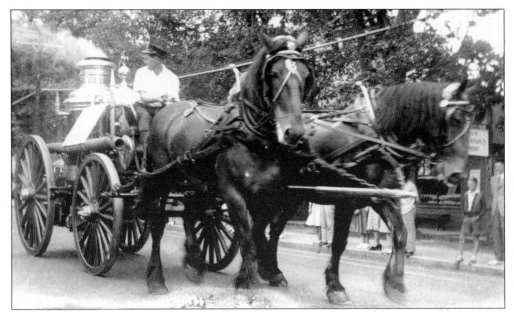

J.D. HILLIARD. Steam, produced in the boiler by a coal fire, powered the fire pump that pressurized the steamer's hose lines. The first attempt to get a steamer was rejected in 1869, when, according to a newspaper account, a "strong headed fellow" opposed the purchase of a steamer on the grounds that "cold water would put out a fire as well as 'biling' water, and there would be no danger of scalding people around the fire." (Hyannis Fire Department collection.)

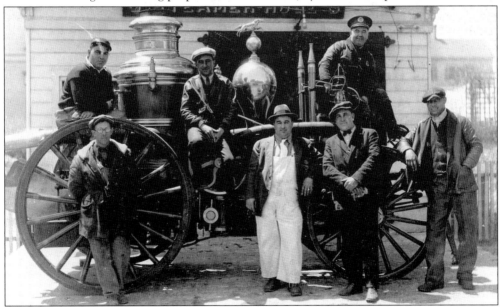

STEAMER AND HOSE COMPANY NO. 3. Initially located on Commercial Street at Pearl Street, the house of Steamer and Hose Company No. 3 was moved in 1902 to 4 Johnson Street (at no cost to the town) in an exchange deal with the Provincetown Cold Storage Company. Pictured in 1918 are, from left to right, the following: (front row) Joe Vieira, Capt. Richard M. Woods, Leon J. Silva, and Lt. Albert J. Avell; (back row) Anthony Alves, Albert Loring, and Lt. Antone Dennis. (Provincetown Fire Department collection.)

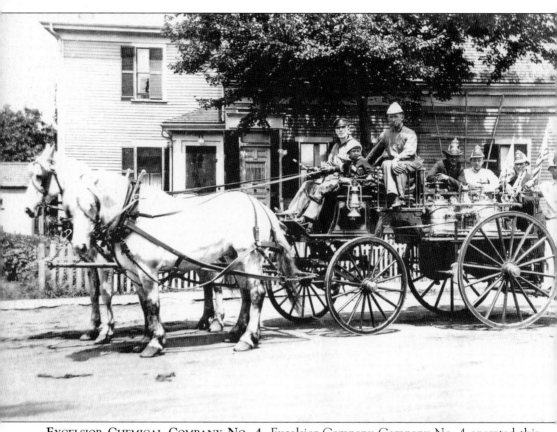

EXCELSIOR CHEMICAL COMPANY NO. 4. Excelsior Company Company No. 4 operated this 1889 horse-drawn chemical and hose apparatus. Chemical apparatus, advertised as being 30 to 40 times more effective at firefighting than water, were popular for 50 years (between the 1870s and the 1930s). Chemical engines had one or more sealed copper tanks (25 to 60 gallons each) that were filled with a solution of water and sodium bicarbonate (baking soda). Upon arriving at a fire, a charge of sulfuric acid was mixed into the water, causing a chemical reaction that rapidly produced carbon dioxide gas. This pressurized the tank and forced a stream of water through the hose and nozzle. Although the "chemicals" did not actually change the effectiveness of the water, the ability to get water onto the fire quickly, while the steamer and hand engines were still setting up, certainly must have saved many buildings and proved the worthiness of the apparatus. The first apparatus of Excelsior Company No. 4 had been one of two 1854 Hunnemans (*Mazeppa No. 3* and *Excelsior No. 4*) bought "used" from the Lowell fire department in 1868. (Provincetown Fire Department collection.)

THE PROVINCETOWN FIRE DEPARTMENT. The 1874 annual report of the Provincetown Fire Department stated, "There is no town in the State that can rally its firemen quicker than we can. Our only safeguard from a destructive conflagration such as have been visited by many cities and towns is by being vigilant and prompt." Fires had devastated Chicago in 1871 and Boston in 1872. In 1875, there were 485 volunteer firemen on the Provincetown Fire Department—230 paid ($5 a year) and 255 unpaid. This represented about 11 percent of the population (4,357) in the congested little town. The department operated five hand-drawn engines, each with a hose carriage, and one hand-drawn hook-and-ladder truck. Rescue Hook and Ladder Company No. 1 operated a ladder carriage built in 1869 by B.A. Ellison in Wellfleet. (Crosby photograph, Provincetown Fire Department.)

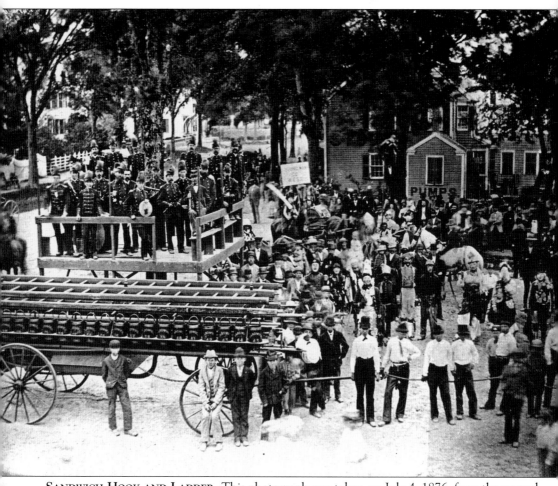

SANDWICH HOOK AND LADDER. This photograph was taken on July 4, 1876, from the second floor of Pope's Store and Post Office, at the intersection of Main and Jarvis Streets. Authorized at town meeting in February 1870, the Sandwich Hook and Ladder carriage was manufactured in Sandwich for $850. Capt. L. Bourne Nye manufactured the wooden parts, and John C. Ellis forged the metal parts. When completed and equipped, it weighed 1,940 pounds and, according to a newspaper account, "had such perfect running gear (Concord axles) that two ordinary men could draw it along any level ground." Equipped with an assortment of ladders, hooks, axes, and at least 45 leather buckets, the truck was housed under town hall. It was hand drawn but would be pulled on long runs by a pair of heavy bay horses owned by William E. Braman, who lived near town hall. This ladder carriage was donated to the Henry Ford Museum in Dearborn, Michigan, in 1927. The town and the Sandwich Glass Factory also had hand engines in the 1800s. (Sandwich Glass Museum collection.)

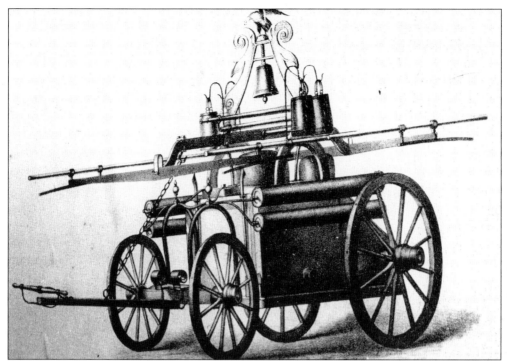

THE FIRST ORLEANS ENGINE. The Orleans town meeting of February 6, 1893, authorized $1,000 to purchase a fire engine and hose reel. Manufactured by Howard and Davis of Boston, the first Orleans fire engine was housed in a small building on the Cummings estate opposite T.A. Smith's store. Two ladders were also hung on the outside of the building. John B. Crowell was the caretaker of the engine. (Orleans Fire Department collection.)

THE HYANNIS FIRE DEPARTMENT. The Hyannis Fire District was established within the town of Barnstable on May 29, 1896. The first district meeting authorized $1,000 to purchase a hand-drawn double-tank (35 gallons each) soda-acid chemical engine, a used hook-and-ladder truck, and four two-gallon hand extinguishers. Included were two sets of hoses. O. Howard Crowell was elected as the first fire chief and organized a 15-man department. (Hyannis Fire Department collection.)

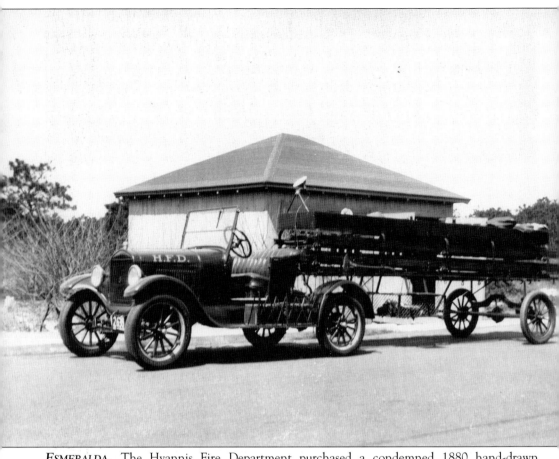

ESMERALDA. The Hyannis Fire Department purchased a condemned 1880 hand-drawn hook-and-ladder wagon from the Brockton Fire Department in 1897. Affectionately known as *Esmeralda*, the truck was motorized in 1924 with the addition of a used Ford Roadster. It served Hyannis until 1932. The first Hyannis engine house (pictured here) was located behind Keveney's store on Main Street, in the area of Center and Elm Streets. The Hyannis Fire Department added a hose carriage in 1899 and a second chemical engine in the west end in 1903. By 1912, there were two hose reels, two chemicals, a hook-and-ladder truck, six extinguishers, and more than 1,000 feet of hose. Around midnight on December 2, 1904, a fire struck the east end of Main Street. By morning, 15 buildings (including the Universalist church) and 600 feet of retail space were in ruins. Help was requested by rail from Provincetown, Middleboro, and Brockton. (Hyannis Fire Department collection.)

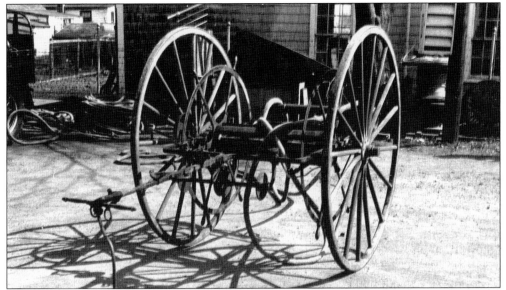

A **FALMOUTH HOSE REEL.** Falmouth approved $700 for a minimal fire department in 1897. Hand-drawn hose reels like the one shown here carried 250 to 500 feet of hose. By 1915, hose companies included Teaticket No. 1 (1897), East Village No. 2 (1897), West Village No. 3 (1897), Quissett No. 4 (1902), Woods Hole No. 5 (1899), West Falmouth No. 6 (1904), Falmouth Heights No. 7 (1904), East Falmouth No. 8 (1907), North Falmouth No. 9 (1907), and Waquoit Chemical No. 1 (1913). (Falmouth Fire Department collection.)

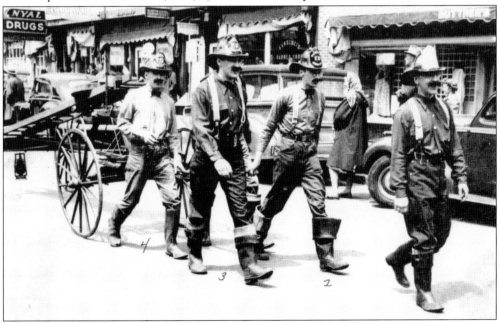

THE **FALMOUTH LADDER COMPANY.** Falmouth had two ladder companies. Ladder 1 (1897) was with Hose 2, and Ladder 2 (1907) was with Hose 4. Here, one of these ladders is being pulled up Main Street in a 1946 parade. Falmouth had all hand-drawn equipment until 1919, when Chief Ray Wells began motorizing the department. Some companies were eliminated or consolidated. By 1922, all hand apparatus was in reserve or storage. (Falmouth Fire Department collection.)

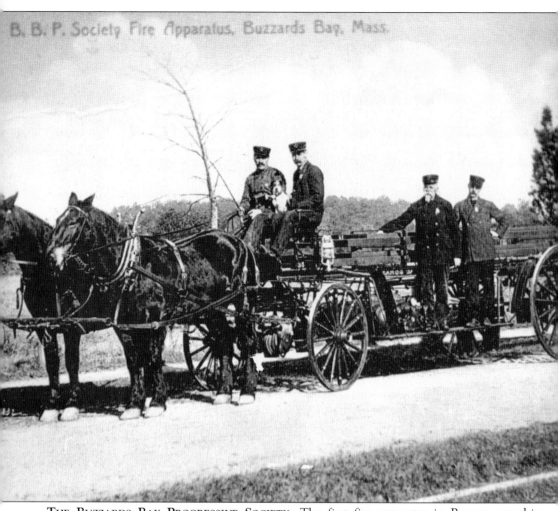

THE BUZZARDS BAY PROGRESSIVE SOCIETY. The first fire apparatus in Bourne was this 30-foot-long horse-drawn carriage (a combination chemical and hook-and-ladder vehicle), purchased by the Buzzards Bay Progressive Society in 1907. Housed in the society's clubhouse (Cohasset Hall on Main Street), it carried several wooden ladders, two soda-acid tanks, several axes, hooks, ropes, lamps, and other equipment. Horses were borrowed when needed. In this view, Sam Tripp is the driver, sitting with Isaac Small and his fox terrier. Orin Harris and Albert Trench stand on the running board.

In 1922, the horse-drawn apparatus was declared obsolete. The chemical tanks were removed and mounted on a used motorized truck. The Buzzards Bay Progressive Society also purchased a Model T chemical engine in 1922. When the Bourne Fire Department was established in January 1925, it took over the apparatus and rented the Cohasset Hall station from the society. (Bourne Fire Department collection.)

THE CHATHAM FIRE DEPARTMENT. The Chatham Fire Department was organized in 1911. The first apparatus in town was this 1911 American LaFrance fire extinguisher wagon. Pulled by a single horse, the wagon carried a dozen or more soda-acid extinguishers. The apparatus was privately housed prior to 1916. After that time, Chatham apparatus was housed in the Eldredge garage at 351 Main Street. This view dates from *c.* 1918. (Chatham Fire Department collection.)

COTUIT CHEMICAL COMPANY NO. 1. On November 15, 1912, fire warden Alexander Seabury Childs and others organized Cotuit Chemical Company No. 1. With a roster of 14 members, the company protected the village of Cotuit from 1912 to 1926. This hand-drawn, two-tank (35 gallons each) chemical fire engine was acquired by subscription. The company also had 12 iron pales and leased an engine house on Main Street. (Walter Dottridge collection, Cotuit Fire Department.)

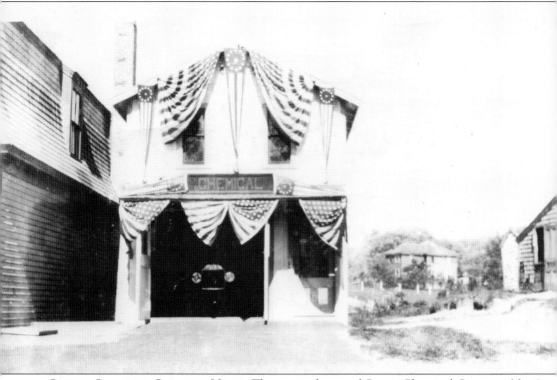

COTUIT CHEMICAL COMPANY NO. 1. The engine house of Cotuit Chemical Company No. 1 was located immediately north of the store at the corner of Main and School Streets (where the park is now). The building was originally the hardware section of Ben Sears's store and was on land leased from Emma Crocker for $10 a year. It housed Cotuit's 1916 Model T chemical engine. When the Cotuit Fire District was established on June 18, 1926, the chemical company was dissolved, and the engine house and Model T were turned over to the district. The building was moved to a lot on High Street in 1929 and served as the district firehouse until a new one was built in 1938. This photograph was taken c. 1919. (Walter Dottridge collection, Cotuit Fire Department.)

Two

FIRE STATIONS

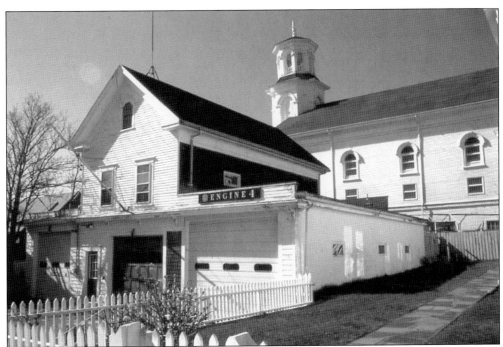

PROVINCETOWN FIRE STATION No. 4. The oldest fire stations on Cape Cod, and the most in any one town, are in Provincetown. Stations were located at 117, 189, 252–256, 351, and 514 Commercial Street. Station numbers changed over the years as apparatus assignments changed, districts were reorganized, or stations were sold. This station was moved to 4 Johnson Street in 1902 for Steamer No. 3. It is one of three active stations today. (Crosby photograph.)

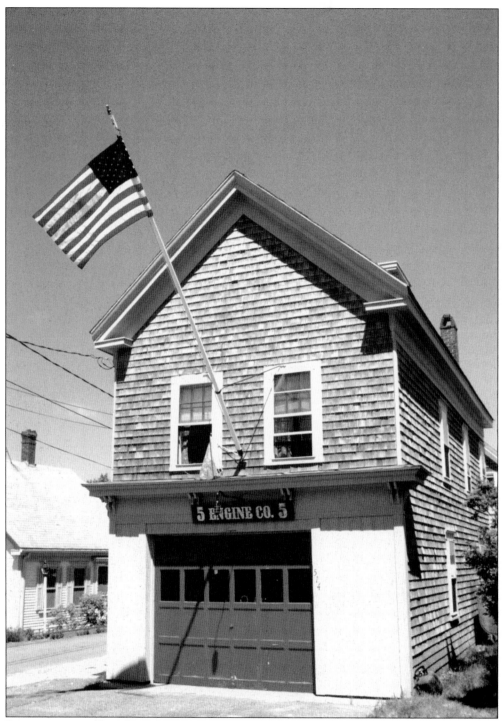

PROVINCETOWN FIRE STATION NO. 5. Provincetown's east end fire station was built in 1869 for Ulysses No. 1. Located at 514 Commercial Street, at the corner of Anthony Street, this is the longest continuously serving fire station on Cape Cod. It was recently renovated and continues to be the active home of Engine Company No. 5. (Crosby photograph.)

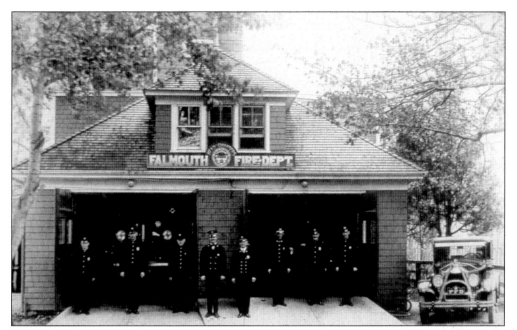

FALMOUTH FIRE HEADQUARTERS. The Falmouth Fire Department built its headquarters on Main Street in Falmouth village in 1913. This wooden firehouse was replaced by a brick headquarters in 1929 but remained on the property as a storage and maintenance facility until 1985. This photograph was taken *c.* 1920. (Falmouth Fire Department collection.)

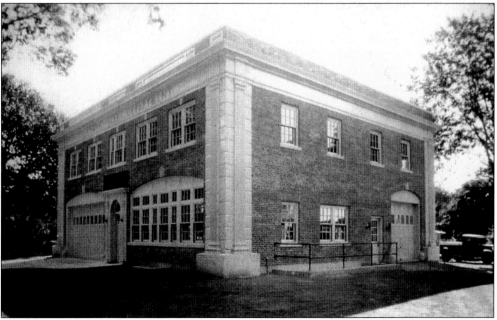

FALMOUTH FIRE HEADQUARTERS. The new Falmouth headquarters was built in 1929 at 399 Main Street (next to the 1913 wooden station). Facing Main Street, the station was built with a modern alarm room and spacious quarters for permanent firemen. Brass fire poles enabled firemen to quickly reach the apparatus when the alarm bells began to ring. (Falmouth Fire Department collection.)

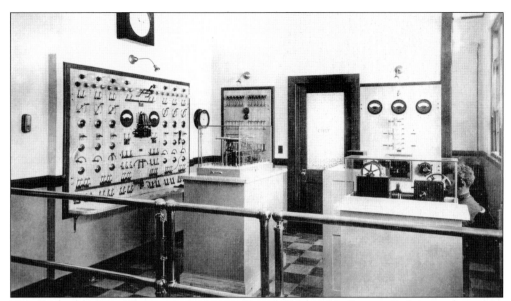

THE FALMOUTH FIRE DEPARTMENT ALARM ROOM. Falmouth's Gamewell alarm system used a network of direct-current circuits around town. When a box was pulled from the street, it sent a series of electrical signals to the alarm room, causing bells to tap out the "box number" and holes to be punched in the reel-to-reel paper register. Alarm bells sounded in the other stations and even at the movie theater to summon firemen. Radios were added c. 1937. (Falmouth Fire Department collection.)

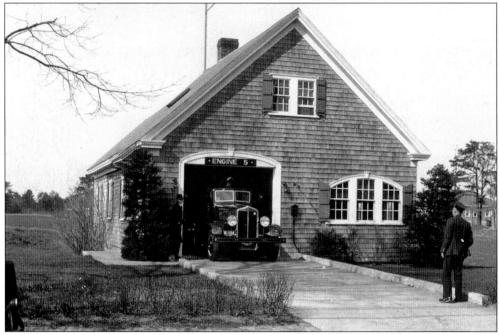

FALMOUTH STATION NO. 5. The East Falmouth fire station was built in 1930. It was located on Route 28, just west of Davisville Road. The 1938 Maxim pumper of Engine 5 is in the doorway. A 1935 Ford 800-gallon tanker was kept behind Engine 5. This station was sold after a new East Falmouth station was built in 1980. (Falmouth Fire Department collection.)

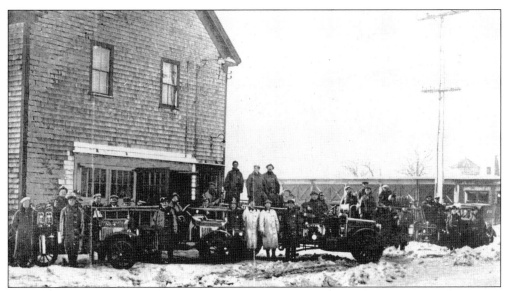

THE BUZZARDS BAY FIRE STATION. Bourne's first fire station, pictured here *c.* 1925, was Cohasset Hall in Buzzards Bay. On September 24, 1931, a fire struck the barn of Geneva Robinson on Lafayette Avenue. Sparks from that fire ignited the roof of Howard Crosby's barn a short distance away. As divided forces battled these two blazes, word came that the fire station was also on fire. With firefighting efforts further hampered by a lack of water and manpower, Cohasset Hall burned to the ground. (Bourne Fire Department collection.)

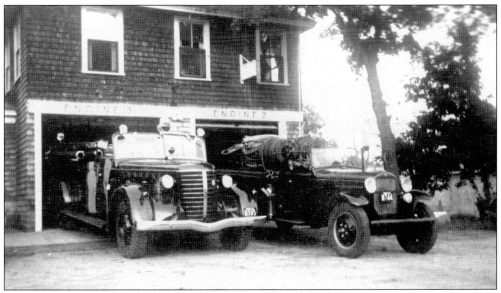

BOURNE STATION NO. 2. The Monument Beach fire station, off Shore Road, was originally the Douglas Stable. Engine 2 (right) was a 1930 Ford Model A that served as a brush truck. Engine 3 was a 1939 Buffalo 600-gallon-per-minute rotary-gear pumper. (Bourne Fire Department collection.)

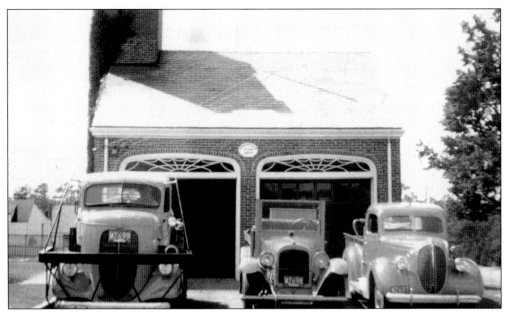

THE OSTERVILLE FIRE STATION. The Centerville-Osterville Fire District was established on January 29, 1926. Fire stations were built at 595 Main Street in Centerville and 999 Main Street in Osterville. The Osterville station housed a 1926 Maxim pumper, Engine 1 (not shown). It also housed town of Barnstable forest fire equipment, including the 1937 Ford 800-gallon, first-ever brush breaker (left), the 1922 Dodge patrol truck (center), and the 1938 Ford patrol truck (right). (Centerville-Osterville-Marstons Mills Fire Department collection.)

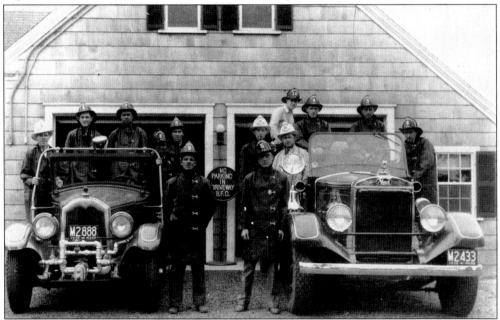

THE BARNSTABLE FIRE STATION. The Barnstable Fire District was established in 1926, but no action was taken to organize a fire department until 1935. This station, built on Main Street, housed a 1935 Mack pumper and a Buick truck, equipped with a tank and pump by the firemen. The first chief was Ray Neil. (Barnstable Fire Department collection.)

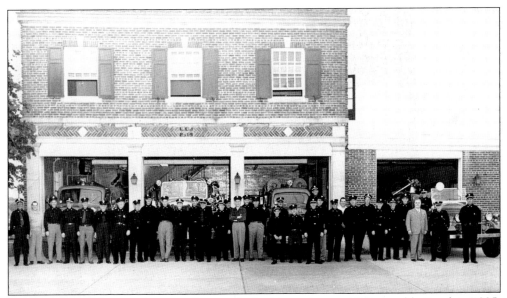

HYANNIS FIRE HEADQUARTERS. Hyannis built this station at 44 Barnstable Road in 1925. Although the station was initially unmanned, operators at the telephone exchange on North Street would take phone calls and would activate the horn and siren to summon firemen. Firemen (and others) would then call the operator to ask, "Where's the fire?" In this *c.* 1950s view, firemen pose in front of the station that housed four engines, a ladder truck, and a rescue truck. (Hyannis Fire Department collection.)

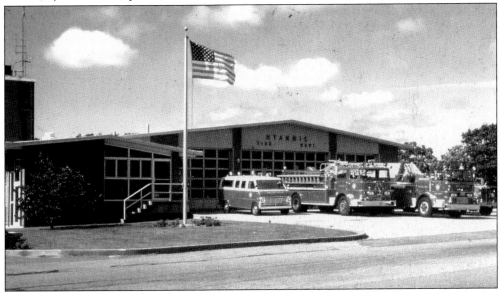

THE NEW HYANNIS HEADQUARTERS. A new Hyannis headquarters was built in 1965. The High School Road station was modern and spacious, complete with a radio room, offices, dorms, hose tower, and a large drive-through apparatus room. The apparatus includes Rescue 87, a 1970 Ford van ambulance; Engine 82, a 1965 FWD Farrar (Engine 2); Ladder 89, a 1968 Thibault 85-foot aerial; and Engine 85, a 1949 Mack (Engine 5). This station (KCD 454) conducted the daily county radio test each morning. The photograph dates from *c.* 1971. (Hyannis Fire Department collection.)

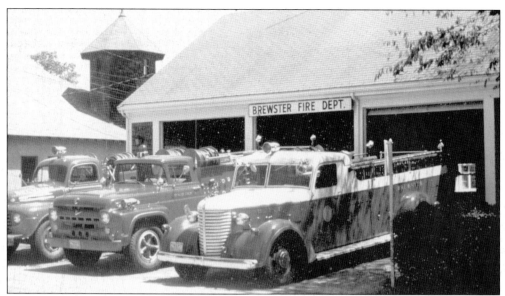

THE BREWSTER FIRE STATION. The Brewster Fire Department, established in 1927, initially housed its apparatus at Dillingham's garage on Main Street. Brewster's first fire station (pictured here) was built in 1941 on Main Street, near Route 137. It served as the fire station until 1974. The apparatus includes Engine 2, a 1949 Ford 500-gallon-per-minute pumper; Engine 1, a 1957 Ford-Maxim 750-gallon-per-minute pumper; and Engine 3, a classic 1941 Buffalo 600-gallon-per-minute rotary-gear pumper. (Brewster Fire Department collection.)

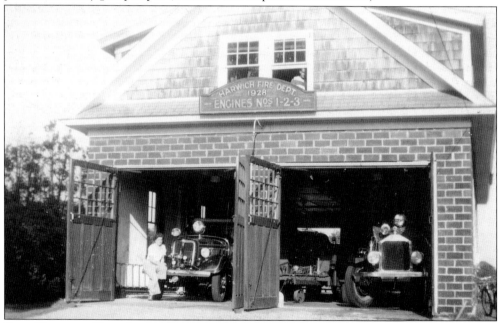

THE HARWICH FIRE STATION. The first Harwich engine was housed in Baker's Garage (Hemeon's) on Route 28, near Bank Street. In 1928, this station was built at 203 Bank Street and served as the Harwich headquarters until 1996. This *c.* 1945 photograph shows the 1930s Ford Engine 2 and a 1927 Maxim (Engine 1 or 3). The sign over the door reads, "Harwich Fire Dept. 1928. Engines No. 1-2-3" (Harwich Fire Department collection.)

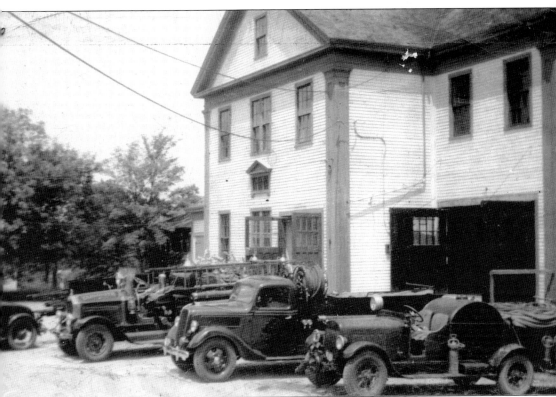

THE YARMOUTH PORT FIRE STATION. The first fire apparatus in Yarmouth was bought after an October 13, 1930 fire in Yarmouth Port destroyed Dr. Henry B. Hart's house on Main Street. Since Yarmouth had no fire equipment, apparatus responded from Hyannis, Falmouth, Dennis, Harwich, and Brewster. This old schoolhouse became home to Yarmouth Fire Company No. 2. Apparatus here includes an old hook-and-ladder truck pulled by a Ford Roadster (the old Hyannis *Esmeralda*), a 1931 Maxim 500-gallon-per-minute pumper, a 1932 Ford brush truck, and a used Reo "laundry truck" made into a tanker brush truck. Yarmouth Company No. 1 kept equipment in Baker's Garage on Old Main Street in South Yarmouth. Both Yarmouth companies operated independently, funding their own equipment, until the town department was organized in 1950. Yarmouth Station No. 2 is now on the site of the old schoolhouse. (Yarmouth Fire Department collection.)

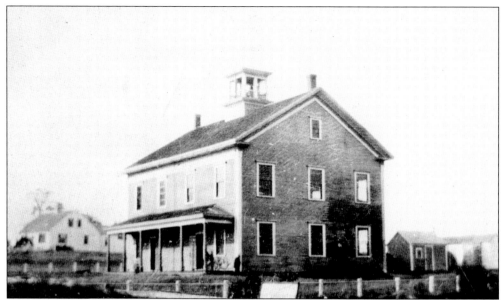

THE SOUTH DENNIS FIRE STATION. Dennis bought fire apparatus *c.* 1930 and officially organized a fire department in 1932. Station No. 1 on the south side of town was in this old schoolhouse at 293 Main Street in South Dennis. A similar schoolhouse on Old Bass Road in North Dennis was called Station No. 2. (Dennis Fire Department collection.)

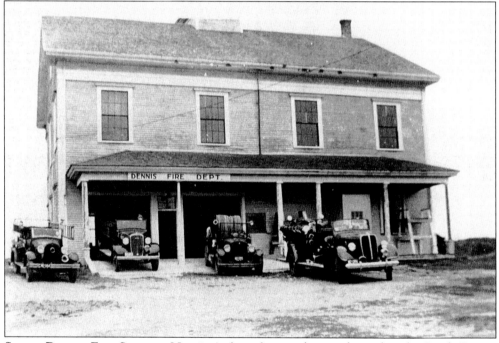

SOUTH DENNIS FIRE STATION NO. 1. At least four trucks were housed in the South Dennis firehouse. The newest at the time of this 1937 photograph was the 1937 Ford Engine 1 (right). Perhaps one of the most unusual apparatus in those days was the Ford Model T (second from right), which carried a large hose reel. This station was used until a new headquarters was built on Route 28 in 1949. (Dennis Fire Department collection.)

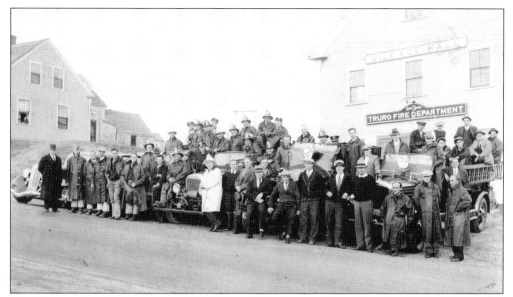

THE TRURO FIRE DEPARTMENT. Col. Richard McGee was Truro's first fire chief and organized the department in the early 1930s. Engine 1 was housed at his home (Cobb Farm) on County Road, South Truro. Station 2 was on Castle Road, Truro Center. Station 3 was in the village hall (originally part of a Provincetown shirt factory *c.* 1870) and moved to North Truro in 1904. This photograph was taken *c.* 1934.

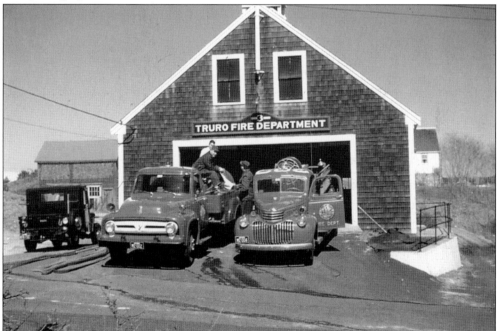

THE NORTH TRURO FIRE STATION. The second floor of the village hall was removed due to rot, and an addition was built to the rear of this station for the ambulance. This is how the North Truro station looked until it was replaced in 1995. The apparatus are a 1954 Ford 800-gallon tanker and a 1943 Chevy-Darley 350-gallon-per-minute, 350-gallon Engine 3. (John W. Garran Sr. collection, Truro Fire Department.)

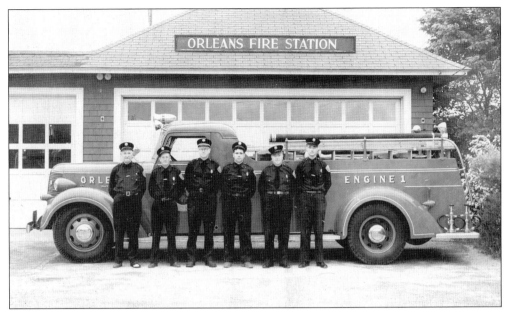

THE ORLEANS FIRE STATION. The Orleans Fire Department officially organized in 1922. The first apparatus was housed at Chief Chester Ellis's home. In 1925, this firehouse was built at 44 Main Street and was used until a new police and fire station was built in the 1960s. In this view, firemen stand in front of their 1940 Buffalo Engine 1. The building is now a community center. (Orleans Fire Department collection.)

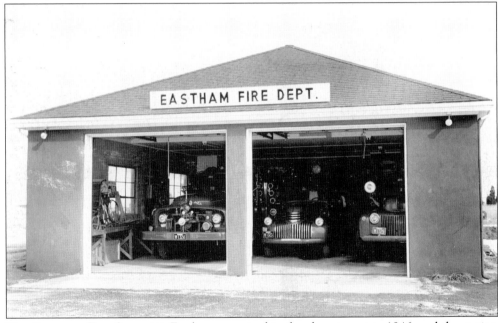

THE EASTHAM FIRE STATION. Eastham organized its fire department in 1946, and the station was built on State Road (Route 6) next to the town hall. The station housed a 1946 Ford Engine 1, a 1942 Chevy (former state patrol truck) Engine 2, and a 1956 Ford-Farrar front-mount pumper Engine 3. A new station was built next to this one in 1960. (Eastham Fire Department collection.)

THE WELLFLEET FIRE STATION. The Wellfleet Fire Department was organized on February 12, 1934. Edward B. Lane was chief and housed the first apparatus in a one-bay garage on Commercial Street (opposite Bank Street) in Wellfleet center. In 1939, this station was expanded to three bays. Later, another two bays were added to the rear. The police and fire departments worked out of here until 1982. This photograph was taken in the 1980s. (Crosby photograph.)

THE MASHPEE FIRE STATION. Mashpee organized its fire department in 1950 in the old District of Mashpee town hall (built c. 1870), on Route 130 across from Great Neck Road. Ellsworth F. Peters was Mashpee's first fire chief. Engine 2 (right) was a 1950 Dodge 800-gallon fire truck. Mashpee moved into a new fire station in 1979. A suspicious fire destroyed the old station on November 2, 1983. (Gordon Peters collection, Mashpee Fire Department.)

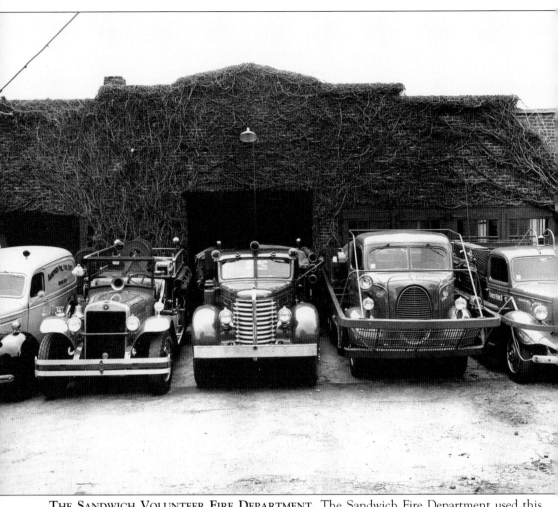

THE SANDWICH VOLUNTEER FIRE DEPARTMENT. The Sandwich Fire Department used this brick garage behind the Daniel Webster Inn as its fire station until 1955, when the town built its first fire station in Sandwich center. Although the Sandwich Fire Department was not "officially" organized until March 6, 1950, the town had bought fire apparatus, staffed by volunteers, from time to time since 1870. The "fire phone" was answered at the Daniel Webster Inn (old Central House), and a siren on top alerted firemen. The Sandwich Volunteer Fire Department Inc., organized in 1951, purchased rescue equipment and operated the Sandwich ambulance from 1952 to 1972. Apparatus in this 1954 photograph includes the 1935 Chevy rescue truck, the 1931 Ahrens Fox Engine 1, the 1947 Diamond T Engine 2, the 1938 Ford-Buffalo brush breaker, and the 1932 Ford forest fire truck. (William "Sparky" Donovan collection, Sandwich Volunteer Fire Department.)

Three

FIRE APPARATUS

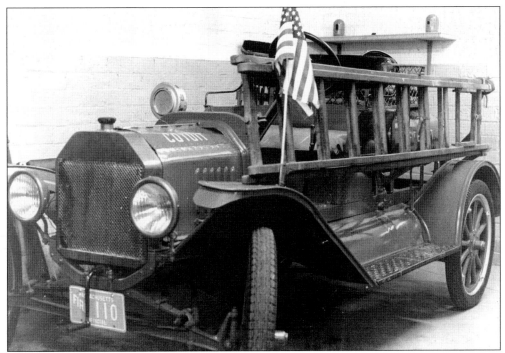

THE COTUIT CHEMICAL COMPANY MODEL T. Cotuit's 1916 Model T–American LaFrance chemical engine was the first motorized fire apparatus on Cape Cod. It had two 25-gallon chemical tanks, a small ladder, and hand tools. The Model T protected Cotuit into the 1930s and was completely refurbished in the 1980s after it caught fire during a Fourth of July parade. (Centerville-Osterville-Marstons Mills Fire Department collection.)

CHATHAM CHEMICAL ENGINE. The Chatham Fire Department bought this "used" 1915 White chemical engine in 1916 for $2,625. It was equipped with a pair of 40-gallon chemical tanks, a ladder, and an assortment of tools. This apparatus was housed in Eldredge's Garage at 351 Main Street. (Chatham Fire Department collection.)

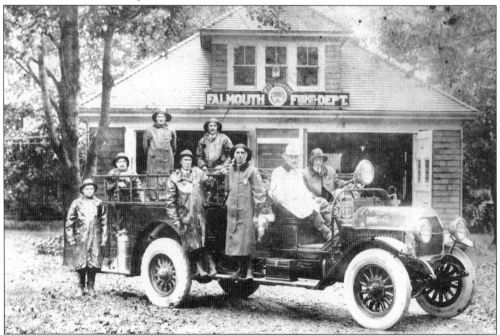

FALMOUTH HOSE 5. This 1919 Maxim hose and chemical engine served as Hose 5 in Woods Hole until c. 1938. Hose 5 was one of the first motorized apparatus in Falmouth. In this photograph, Chief Ray D. Wells poses with firemen in front of the Falmouth headquarters. (Falmouth Fire Department collection.)

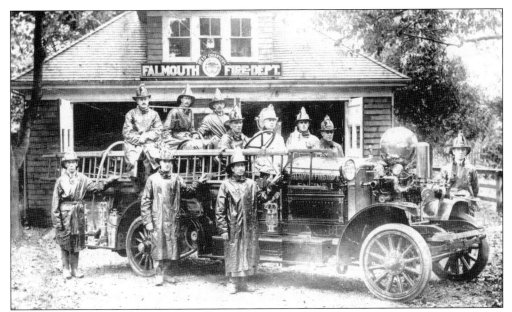

FALMOUTH ENGINE 1. This 1920 Ahrens Fox chain-drive (see rear wheel) pumper served as Engine 1 in Falmouth village from 1920 until 1956. It had a 750-gallon-per-minute piston pump and 50-gallon water tank. The steering wheel was on the right. Falmouth bought another Fox 1,000-gallon-per-minute pumper for Engine 2 in Woods Hole in 1927. (Falmouth Fire Department collection.)

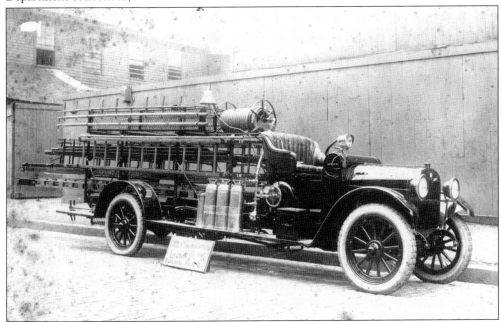

FALMOUTH LADDER 1. The first motorized ladder truck in Falmouth was this 1922 Reo built by the Combination Hook and Ladder Company in Providence. Ladder 1 carried a large complement of wooden ladders (including a 50-footer) and plenty of hooks, poles, and tools. It had a chemical tank and carried an assortment of soda-acid extinguishers. Ladder 1 was assigned to headquarters until 1931. (Falmouth Fire Department collection.)

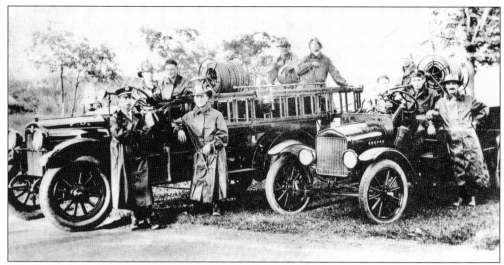

NORTH FALMOUTH APPARATUS. The North Falmouth Station No. 3 was built in 1915. Early apparatus included a 1922 Ford combination pumper Hose 9 and a 1925 Reo chemical engine. Some apparatus was purchased with funds from the sale of closed firehouses after the department reorganized in 1919. There was one permanent man in North Falmouth by 1922. (Falmouth Fire Department collection.)

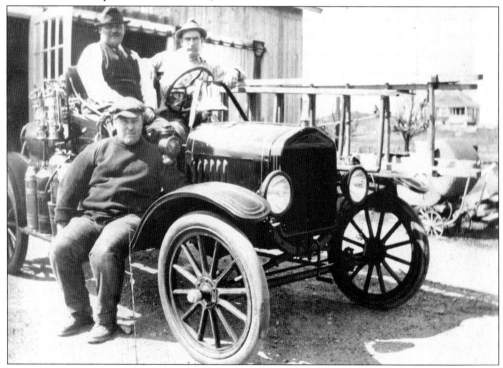

BOURNE ENGINE 4. Alonzo Sampson, Elton Cook, and Harold Champion pose with the new Sagamore fire engine, delivered at 2:00 p.m. on April 16, 1925. The Model T chemical engine was housed in Harold Champion's barn on Old Plymouth Road. It was equipped with 100 pounds of soda, nine gallons of acid, eight hand extinguishers, four shovels, three lanterns, three rubber coats, a first-aid kit, and a ladder. (Bourne Fire Department collection.)

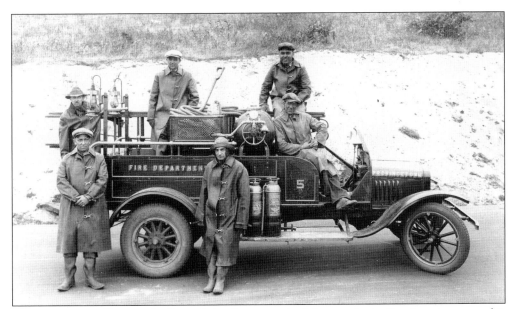

PROVINCETOWN ENGINE 5. One of the first motorized fire trucks in Provincetown was this 1925 Model T Ford chemical engine. It was equipped with a chemical tank, several soda-acid extinguishers, lanterns, and a ladder. Provincetown bought several Model T apparatus in the mid-1920s as they began to motorize the department. This photograph was taken *c.* 1928. (Provincetown Fire Department collection.)

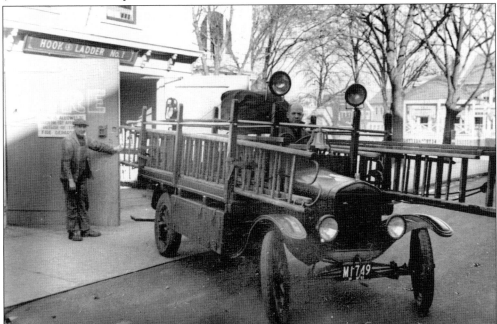

THE PROVINCETOWN HOOK AND LADDER. This 1925 Model T ladder truck replaced Provincetown's 1859 hand-drawn hook and ladder. Housed on Commercial Street (252-256), it served as Provincetown's hook-and-ladder company until *c.* 1942, when a replacement was approved but apparently never bought. Several large ladders were carried on both sides of this little truck. This photograph was taken *c.* 1938. (Provincetown Fire Department collection.)

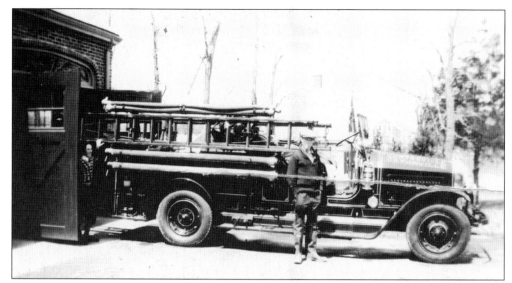

CENTERVILLE-OSTERVILLE ENGINE 1. The first two fire engines bought by the Centerville-Osterville Fire District were 1927 Maxims. Engines 1 and 2 were each 500-gallon-per-minute pumpers equipped with a standard complement of hose, ladders, hard suction, lamps, and equipment. Both trucks were bought for $17,800 and remained in service until 1950. Here, Charles W. Lovell (age 15) stands with Engine 1. Lovell went on to serve 50 years as a call fireman, retiring in 1976 at age 65. (Centerville-Osterville-Marstons Mills Fire Department collection.)

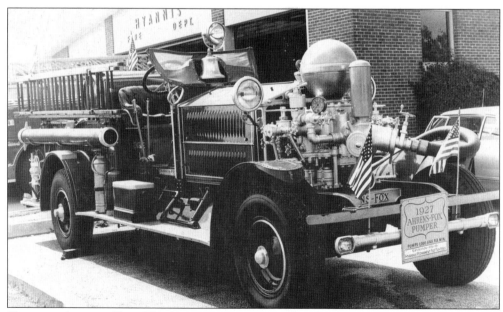

HYANNIS AHRENS FOX. The Hyannis Fire District bought this powerful 1,000-gallon-per-minute Ahrens Fox piston pumper in 1927. Engine 1 was a mainstay of the department, pumping at hundreds of fires in Hyannis and around the Cape for nearly 40 years. It was even called back into duty to pump at fires after its retirement. The Fox was refurbished in the 1970s and is still proudly owned by the department. (Centerville-Osterville-Marstons Mills Fire Department collection.)

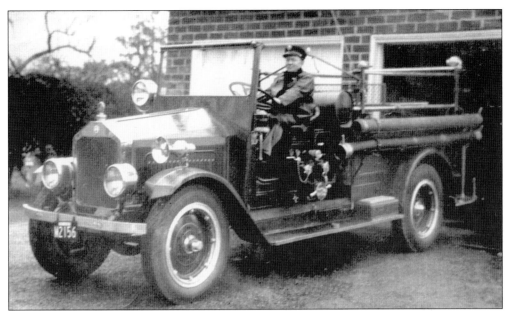

A HARWICH ENGINE. The Harwich Fire Department bought a Maxim 500-gallon-per-minute pumper in 1927. It is believed that Harwich owned two Maxims in the late 1920s—Engines 1 and 3 (it is uncertain which is pictured here). Engine 3, refurbished and painted white for a 1960s town anniversary, is once again being refurbished by the department for parades. (Harwich Fire Department collection.)

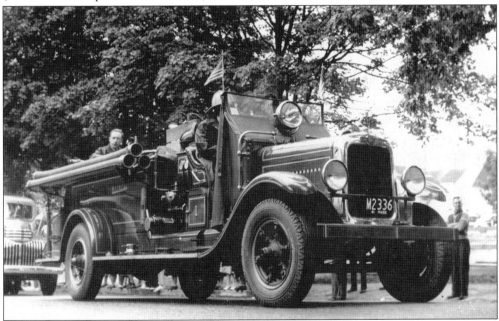

WELLFLEET ENGINE 1. This 1929 American LaFrance 500-gallon-per-minute pumper was Wellfleet Fire Department Engine 1. This engine had a small water tank, so Wellfleet, with no water system, also bought a tanker soon after this engine was bought. The engine would lay out its bed of hose and pump water back to a fire from the nearest pond or cistern. It is shown here in a parade in the 1940s. (Wellfleet Fire Department collection.)

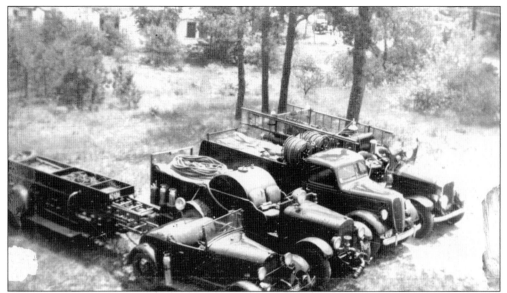

YARMOUTH PORT APPARATUS. This photograph, taken from the old schoolhouse fire station, shows the apparatus of Company No. 2 in Yarmouth Port. The 1931 Maxim (right) was one of two bought that year. Other apparatus, bought or built by the firemen, include a Ford tank truck, a former laundry truck (with 100,000 miles on it) used as a brush truck, and the old ladder truck *Esmeralda,* disposed of by Hyannis in 1932. (Yarmouth Fire Department collection.)

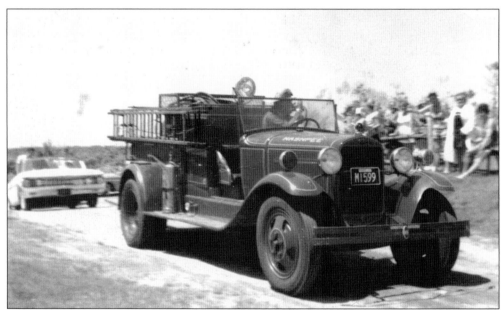

MASHPEE ENGINE 1. The first fire engine in Mashpee was this 1930 Ford Model A pumper bought in 1943 from Centerville (old Centerville-Osterville Engine 3). It had a 75-gallon-per-minute pump and 200-gallon water tank. Mashpee forest warden Edwin L. White stored the engine in his garage on Meetinghouse Way. It became Mashpee Engine 1 at the fire station in 1950, serving there until 1958. This photograph dates from *c.* 1961. (Gordon Peters collection, Mashpee Fire Department.)

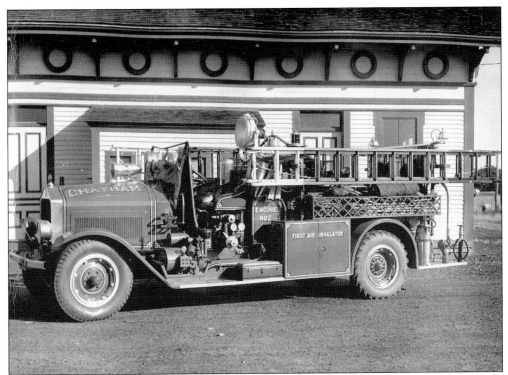

CHATHAM ENGINE 2. The Chatham Fire Department bought many Maxims between 1926 and 1975. Engine 2 (shown here) was a 1931 Maxim 500-gallon-per-minute pumper. It had ladders, a generator, a large spotlight, salvage covers, and brush brooms. Engine 2 probably responded first to the scene. Engine 1, a 1926 Maxim 500-gallon-per-minute pumper equipped with more hard suction hose, probably supplied water. (Chatham Fire Department collection.)

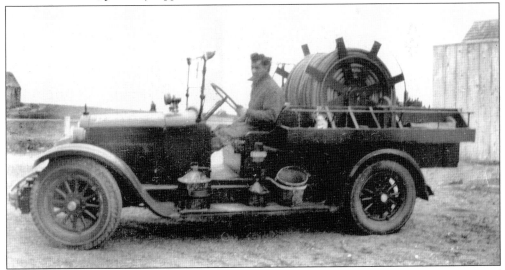

A DENNIS HOSE REEL. Little is known about the history of this unique Model A Ford owned by the Dennis Fire Department in the 1930s. It was equipped with a large hose reel. This uncommon feature probably carried several hundred feet of forestry hose. It was stationed in South Dennis. (Dennis Fire Department collection.)

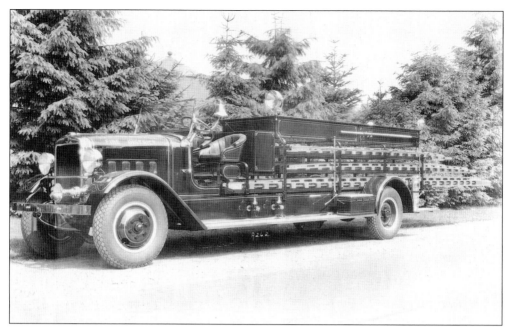

HYANNIS LADDER 1. The Hyannis Fire District replaced old *Esmeralda* with this 1932 Maxim city service ladder truck. The new Ladder 1 had a booster pump, 200-gallon tank, deck gun, life net, and 297 feet of wooden ground ladders. It served in Hyannis for 36 years, finally being replaced in 1968 by a new aerial ladder truck. (Howie Smith's Maxim collection.)

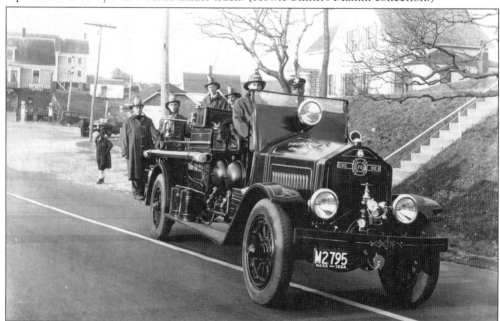

TRURO ENGINE 1. The Truro Fire Department's Engine 1 was a 1930s Maxim combination chemical engine. It had two chemical tanks and a small front-mount pump. Engine 1 was housed in Chief Richard McGee's garage in South Truro. This photograph was taken in 1934 on County Road. The village hall firehouse is in the upper left corner. (Lorne Russell collection, Truro Fire Department.)

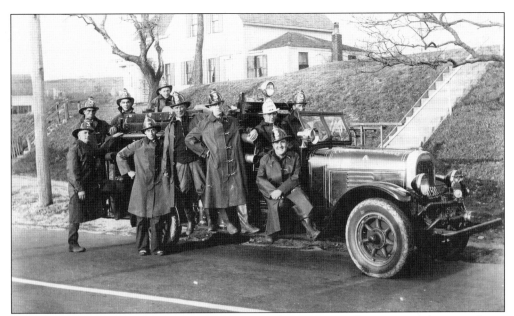

THE TRURO FIRE DEPARTMENT ENGINE "A." The Truro Fire Department also owned two Brockway pumpers in 1934. Engine A (shown here) had a front-mount pump, hard suction hose, and a ladder. Engine B was a similar engine. Little is known about Engines A and B. This was not a common designation, and the fact that Truro also had an Engine 1 would lead one to think these engines may have been bought used. (Lorne Russell collection, Truro Fire Department.)

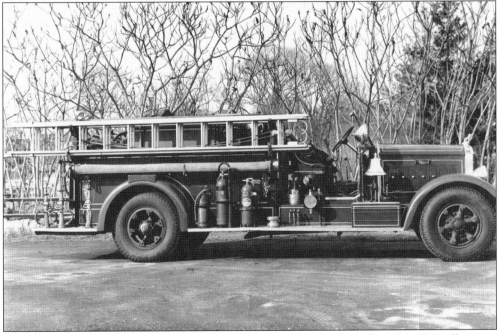

BARNSTABLE ENGINE 1. Barnstable's first pumper was this 1935 Mack with a 500-gallon-per-minute pump and small booster tank. It carried hose, ladders, extinguishers, and an assortment of tools. This engine was retired in 1965. It is still used by the department for parades. (Barnstable Fire Department collection.)

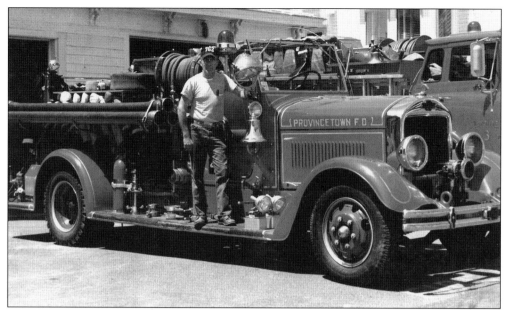

PROVINCETOWN ENGINE 4. Provincetown bought a number of American LaFrance engines in the 1930s and 1940s. Engine 4, bought in 1936, had a 500-gallon-per-minute pump and carried a full assortment of equipment, including protective clothing for the assigned members. Paul Santos is shown with the engine in front of the Johnson Street station. Engine 4 served 40 years, retiring in 1976. It is now being restored for parades. (Provincetown Fire Department collection.)

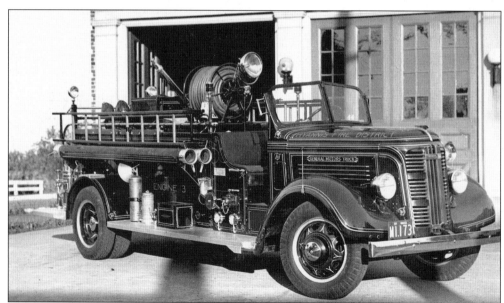

HYANNIS ENGINE 3. Hyannis's Engine 3 is an example of a "commercial" pumper. The Darley 500-gallon-per-minute pumper was built on a 1937 General Motors chassis. Commercial chassis tended to be less expensive than "custom" apparatus. This pumper had a 200-gallon tank and carried 1,200 feet of 2½-inch hose. It served at both the Hyannis and Hyannis Port fire stations. In 1954, the body was remounted on a Dodge chassis, and it served until 1975. (Hyannis Fire Department collection.)

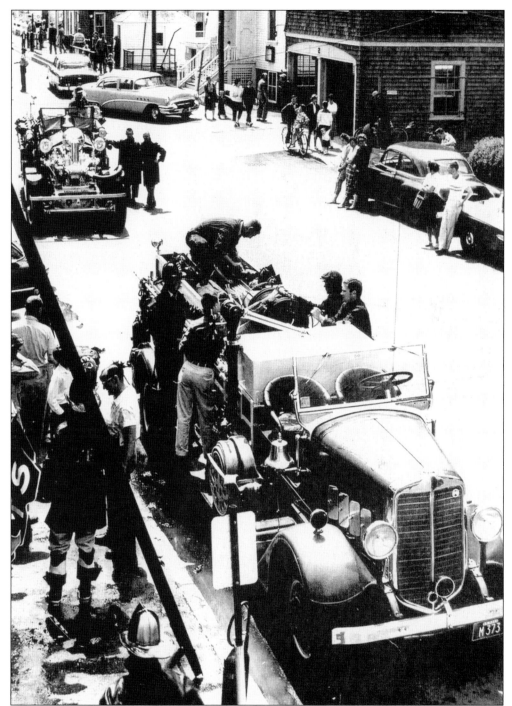

FALMOUTH LADDER 2. Woods Hole Station No. 2 (upper right) was home to a 1927 Ahrens Fox 1,000-gallon-per-minute Engine 2 and a 1938 Maxim city service Ladder 2. The ladder truck had a pump, tank, and large deck gun. Units are picking up here from a fire on Water Street. The Fox is still owned by the Falmouth Fire Department, and Ladder 2 served until the 1990s. (Falmouth Fire Department collection.)

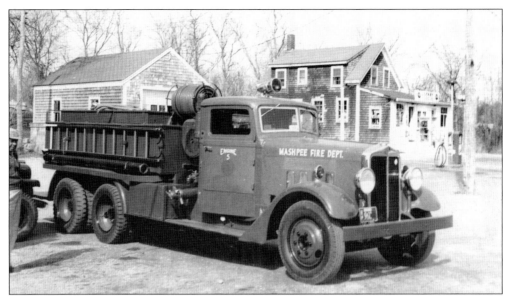

MASHPEE ENGINE 5. Originally Falmouth Engine 5, this 1938 Maxim 500-gallon-per-minute pumper was bought by the Mashpee Fire Department in September 1963. The unusual-looking engine had tandem rear axles to support the weight of its 1,000-gallon water tank. It served as Mashpee Engine 5 until 1970. (Gordon Peters collection, Mashpee Fire Department.)

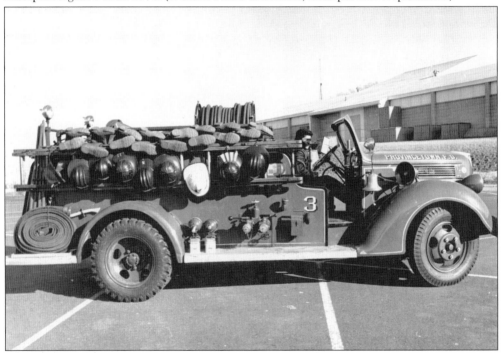

PROVINCETOWN ENGINE 3. Maxim built this 500-gallon-per-minute pumper for Provincetown Engine 3 on a 1940 Ford chassis. The interesting thing about this 1964 picture is how at least nine sets of coats, boots, and helmets were stuffed behind and hanging from the ladder. All of Provincetown pumpers carried the gear of members to the scene this way. Boots were red, so the chief could tell if they were being worn for clamming. (Provincetown Fire Department collection.)

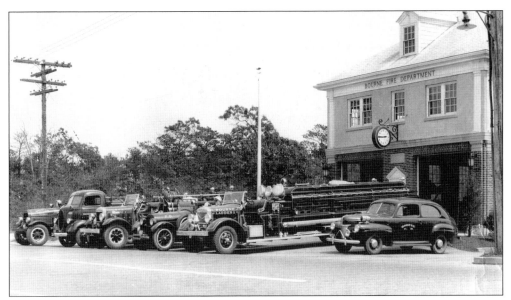

THE BOURNE FIRE DEPARTMENT. The Buzzards Bay fire station was built on Main Street in 1933 where Cohasset Hall once stood. The apparatus included a 1928 Reo engine, a 1939 Ford 250-gallon state forest fire truck, a 1934 Buffalo 600-gallon-per-minute Engine 1, a 1924 Maxim hose wagon, and a 1938 Buffalo city service Ladder 1 equipped with a pump, tank, and generator. The chief's car was a Chevy. This photograph was taken *c.* 1941. (Bourne Fire Department collection.)

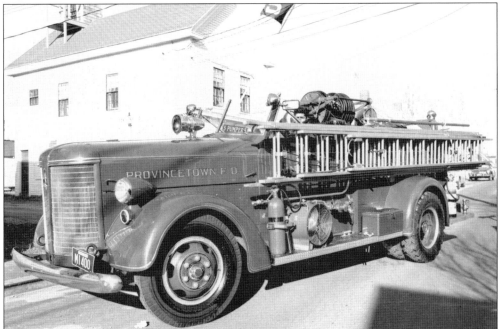

PROVINCETOWN ENGINE 5. This American LaFrance 600 series pumper was one of two bought by Provincetown in 1945. Engines 1 and 5 were impressive-looking and had large V-12 motors, yet they had only 200-gallon-per-minute pumps and 500-gallon tanks. Engine 5, shown *c.* 1964 in front of its east end firehouse, served until 1976. (Provincetown Fire Department collection.)

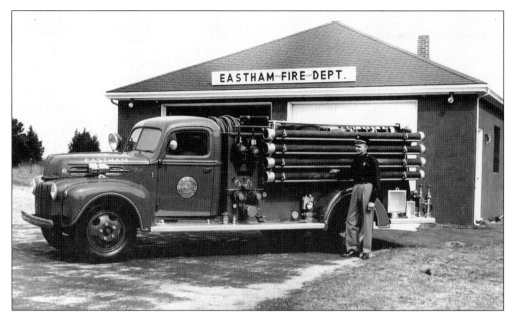

EASTHAM ENGINE 1. Eastham's first fire engine was this 1946 Ford-Maxim 500-gallon-per-minute pumper with a 500-gallon tank. Eastham's Chief John Hilferty stands with Engine 1 in front of the station. The engine served for many years and was recently completely refurbished by the Eastham Fire Association. (Eastham Fire Department collection.)

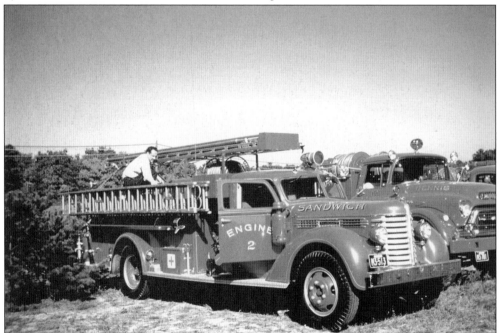

SANDWICH ENGINE 2. This 1947 Diamond T pumper, built by Woods Engineering, was Engine 2 in Sandwich. It had a 500-gallon-per-minute pump and a 500-gallon tank and carried a 40-foot ladder in its overhead ladder rack. Initially housed in the Daniel Webster garage, it was moved to Canning's Garage in East Sandwich in 1957, where it served until 1970. (Sandwich Fire Department collection.)

THE WEST BARNSTABLE FIRE DEPARTMENT. The West Barnstable Fire District was established in July 1949. Members pose with the first West Barnstable Fire Department Engine 1. It was housed in Atwood's Garage on Route 6A until a small two-bay station was built next door. The town stationed some forest fire equipment in the village before the department was established. A county brush breaker was also housed in West Barnstable. (West Barnstable Fire Department collection.)

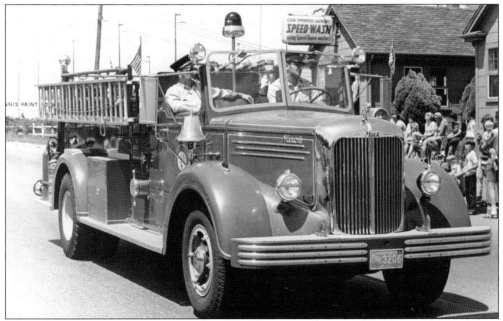

HYANNIS ENGINE 5. Another classic Hyannis engine was this 1949 Mack L model. Engine 5 had a 750-gallon-per-minute pump and 275-gallon tank. "The Mack" would typically lay supply hose and pump from the hydrant, as other engines with larger tanks operated at the scene. Engine 5 remained in service into the 1990s and is still owned by the department. This photograph dates from *c.* 1972. (Hyannis Fire Department collection.)

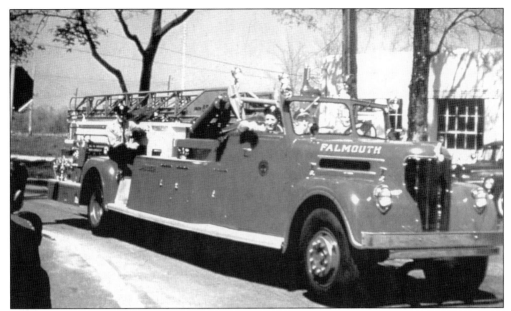

FALMOUTH LADDER 1. Falmouth bought the first aerial ladder truck on Cape Cod in 1949. Ladder 1 was a Maxim 65-foot aerial ladder. Housed at Falmouth Station No. 1, it was the only aerial ladder in service on Cape Cod until 1968, when Hyannis bought one. The Falmouth truck was replaced in 1969 by an American LaFrance 100-foot aerial. (Falmouth Fire Department collection.)

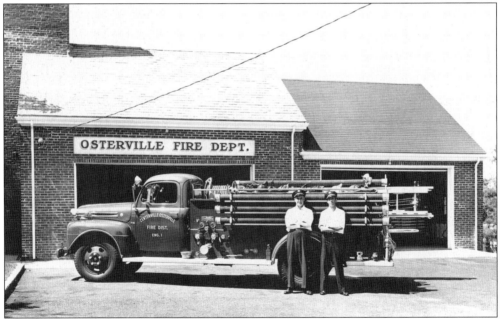

CENTERVILLE-OSTERVILLE ENGINE 1. Deputy Herbert Coombs (left) and Chief Charles Hallett stand with Osterville's new Ford Engine 1 in 1950. Centerville-Osterville replaced its two 1926 Maxims in 1950 with Ford-Maxim 500-gallon-per-minute pumpers. Engines 1 and 2 had 500-gallon tanks and served until 1968–1969. (Centerville-Osterville-Marstons Mills Fire Department collection.)

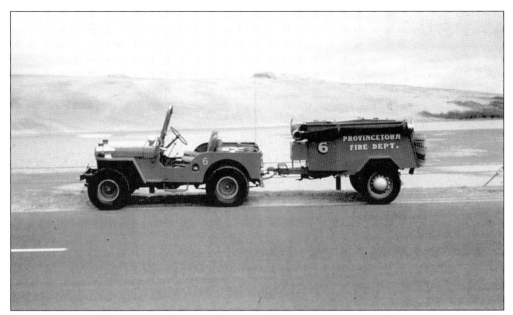

PROVINCETOWN ENGINE 6. As part of a civil defense appropriation, Provincetown put this 1950 Willys Jeep and 500-gallon-per-minute trailer in service as Engine 6. At the time, the 500-gallon-per-minute trailer was able to pump twice what some engines could. It could be towed through Provincetown's tight streets and across the sandy beach to draft from the harbor. (John W. Garran Sr. collection.)

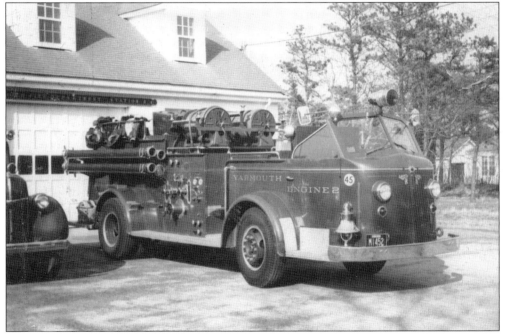

YARMOUTH ENGINE 2. This American LaFrance 700 series pumper was bought by the Yarmouth Fire Department in 1953. Engine 2 had a 750-gallon-per-minute pump and 300-gallon tank. It was assigned to Yarmouth Port. Another 1953 LaFrance was bought by the Harwich Fire Department as Engine 3. (Yarmouth Fire Department collection.)

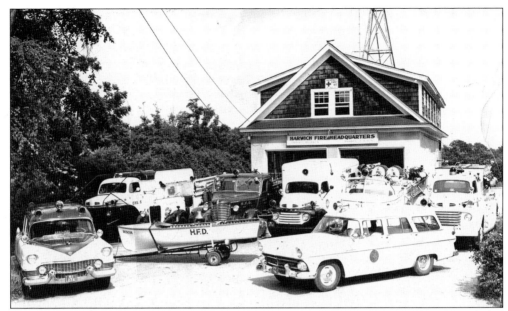

THE HARWICH FIRE DEPARTMENT. The Harwich Fire Department's apparatus in 1955 included a 1952 Cadillac ambulance, a 1950 Ford-Robinson 1,500-gallon brush breaker Engine 5, a 1930s Ford Engine 2, a 1941 Buffalo 600-gallon-per-minute Engine 4, a 1949 Ford Rescue 1, a 1953 American LaFrance Engine 3, a 1948 Ford-Farrar 300-gallon city service Ladder 1, a 1950 Ford chief's car, and the rescue boat. (Harwich Fire Department collection.)

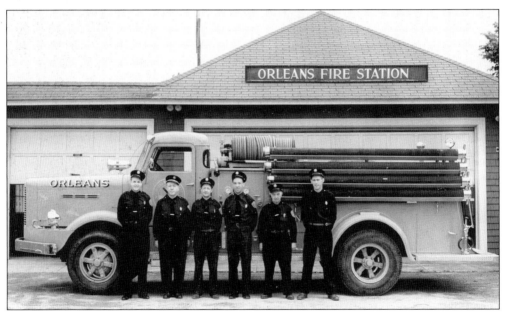

ORLEANS ENGINE 2. Orleans bought this FWD all-wheel-drive pumper in 1954 after apparatus had difficulty responding to a fire that destroyed the library during a blizzard in February 1952. The pumper had a 750-gallon-per-minute pump and carried 800 gallons of water. It also had a high-pressure fog pump with booster reels. Pictured, from left to right, are Emery Soule, Lloyd Ellis, Ed Rogers, Ed Nichols, Lester Quinn, and George Landers. (Orleans Fire Department collection.)

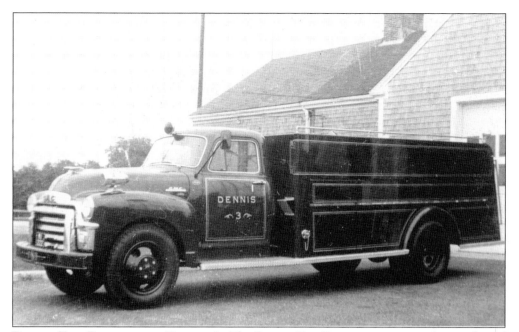

DENNIS FIRE DEPARTMENT ENGINE 3. The Dennis Fire Department operated a number of commercial apparatus, similar in style to this 1954 General Motors vehicle. Engine 3 had a pump and carried about 800 gallons of water. This engine was assigned to headquarters. (Dennis Fire Department collection.)

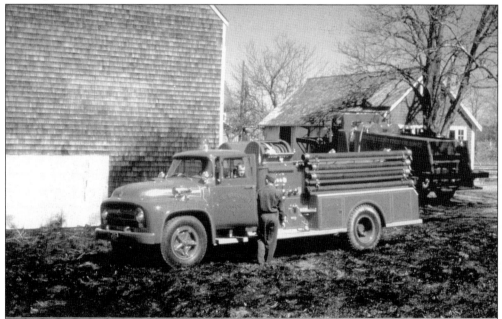

WEST BARNSTABLE ENGINE 1. This 1956 Ford–John Bean 500-gallon-per-minute pumper also had a high-pressure fog pump. It carried 500 gallons of water. Engine 292 was West Barnstable's only pumper until it was replaced in 1979. It is still owned by the department. The county brush breaker C-14 was also housed at the West Barnstable station. (West Barnstable Fire Department collection.)

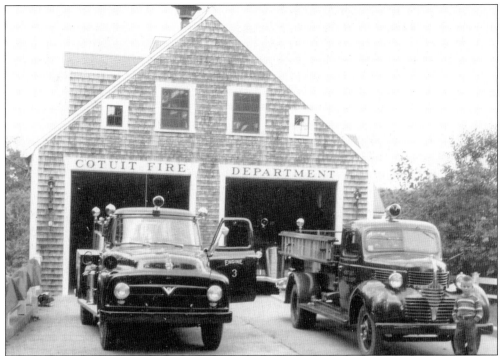

THE COTUIT FIRE DEPARTMENT. Cotuit's apparatus is shown on the ramp of the High Street fire station in 1954. Engine 3 (left) was a 1953 Ford-Maxim. Engine 2 (right) was a 1940s Dodge pumper. Engine 1 (inside) was a 1937 Diamond T pumper. This High Street station was built in 1937. (Walter Dottridge collection, Cotuit Fire Department.)

THE OTIS FIRE DEPARTMENT CRASH STATION. The Otis Fire Department was established in the 1940s to protect the base. One of five stations used at one time, it was located in the 3100 area (west side) of the airfield. Apparatus included a 1944 Diamond T brush breaker (1,000 gallons), a 1954 Ward 750A pumper, a 1946 O-1 Cardox truck, a 1952 O-10 crash truck (500 gallons), a 1953 O-11A crash truck (1,000 gallons), and another 1952 O-10. (Calvin Hitchcock collection, Otis Fire Department.)

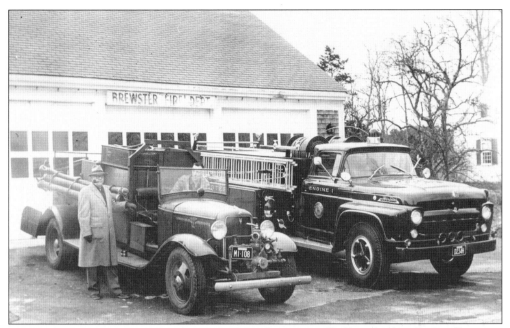

THE BREWSTER FIRE DEPARTMENT. Chief Frank H. Jones (left) and John McCandless pose with Brewster's first engine, a 1932 Ford front-mount pumper. The old engine was being replaced by the new 1957 Ford-Maxim 750-gallon-per-minute Engine 1. (Brewster Fire Department collection.)

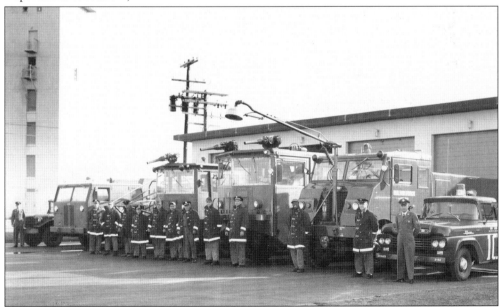

THE NEW OTIS CRASH STATION. Some 120 personnel were on the Otis Fire Department during the Kennedy years (1960–1963). This new crash station and control tower were built in 1960. From left to right are a military ambulance, a 1954 Ward 750A pumper, a 1944 Diamond T breaker, a 1952 American LaFrance O-10 crash truck, a 1953 O-11 crash truck (dual turrets), a new O-6 Cardox truck (4,000 pounds of carbon dioxide) with hydraulic boom, and the Ford pickup of Chief George Cahoon. (Calvin Hitchcock collection, Otis Fire Department.)

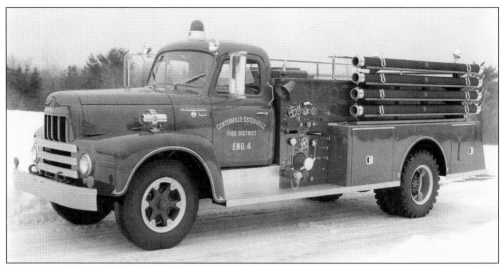

CENTERVILLE-OSTERVILLE ENGINE 4. This 1963 International-Maxim 750-gallon-per-minute pumper had a 500-gallon water tank and was equipped with two foam tanks. Engine 4 was assigned to the Osterville station from 1963 to 1983. It was sold to a small department in Vienna, Maine. The author has fond memories of riding the back step of this engine. Driving it with a nonsynchromesh five-speed was another story. (Howie Smith's Maxim collection.)

"THE BACK STEP," DENNIS ENGINE 1. The back step of Dennis's 1963 Ford-Maxim 750-gallon-per-minute pumper was typical of the era. There was room for three or four men to stand between the hard suction hose and the ground ladders. The gated wye supplied 1 1/2-inch preconnect. The hose bed was packed full of 2 1/2-inch or 3-inch double-jacketed cotton hose. A skid load was carried on the deckboards. (Dennis Fire Department collection.)

Four

FOREST FIRES

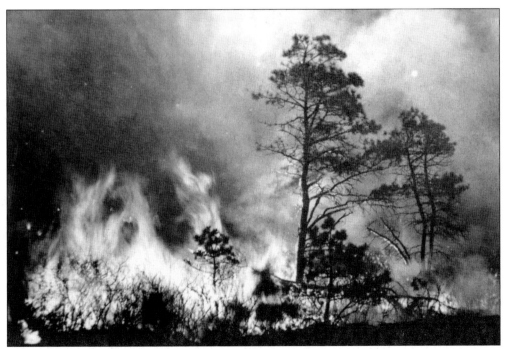

CAPE COD FOREST FIRES. History shows that Cape Cod's forests have been struck many times by huge forest fires. In 1780, "the Dark Day" fire burned from Pocasset to Sandwich. In 1887, 25,000 acres were burned in Bourne and Sandwich. In 1923, another fire in that area destroyed 25,000 acres over seven days. The warm southwest winds of the spring fanned these fires, and there was no way to fight them. (Centerville-Osterville-Marstons Mills Fire Department collection.)

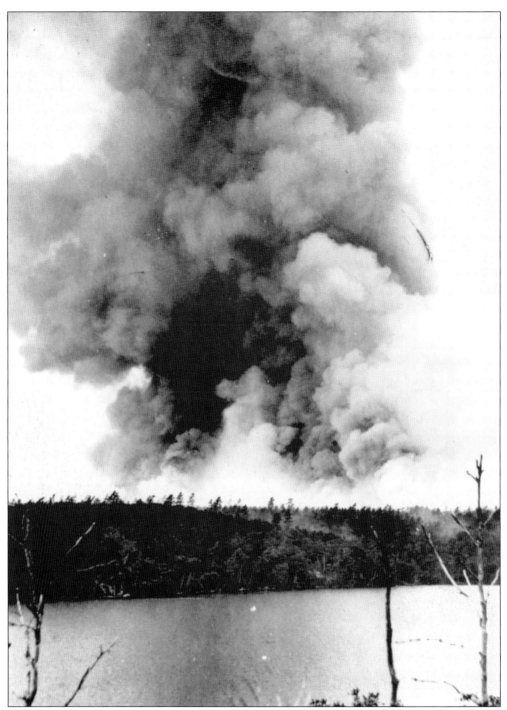

FOREST FIRES. The scrub oak and pitch pine forests were explosive under certain conditions. When fires began, it was possible for 50 acres or more to burn per minute. Early settlers burned off underbrush by "firing the woods" each year in the off-season to reduce the low fuel load and slow the spread of fires. Tremendous amounts of choking woods smoke would fill the air for days. (Centerville-Osterville-Marstons Mills Fire Department collection.)

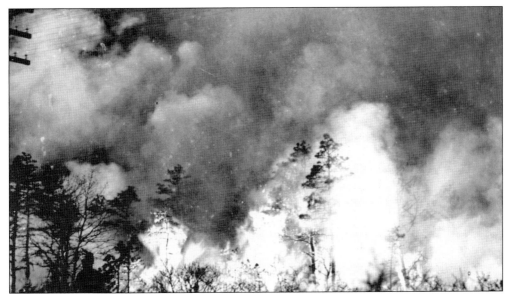

THREE MEN KILLED. One of the worst forest fires ever on Cape Cod killed three men and injured several others in Sandwich on April 27, 1938. Thomas Adams, 43, Gordon King, 34, and Ervin Draber, 28, all died from burns received while fighting the fire. They were overtaken by the fire fanned by 40-mile-per-hour winds. A memorial stands today on Route 130 in Forestdale to commemorate their sacrifice. (Centerville-Osterville-Marstons Mills Fire Department collection.)

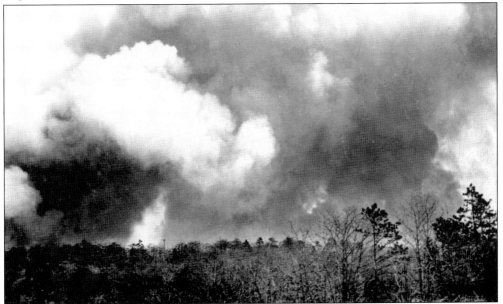

FOREST FIRES. One of the problems with fighting these fires was getting to them while they were still small. Often, the fires had grown large before anyone even noticed them. Telephones were not common, and radios did not come along until the 1930s. The few fire trucks were small, carried little water, and took a long time to reach fires over bad roads. Fighting these fires by hand was dangerous and took many men. (Centerville-Osterville-Marstons Mills Fire Department collection.)

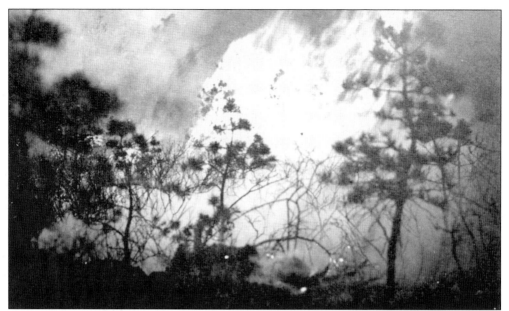

CROWNING. As fires grew, a phenomenon called "crowning" would occur. Fire would travel across the top of the trees at an explosive rate. Trying to fight these fires by "making a stand" in front of them was dangerous and usually ineffective. Stopping these fires was important, and many men worked for days on end to control these fires at great personal risk. (Centerville-Osterville-Marstons Mills Fire Department collection.)

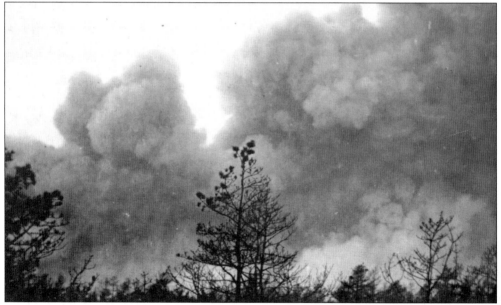

FIGHTING FOREST FIRES. Cape Cod's forest fire problem was studied in the 1920s as part of a national fire-prevention program. Ways to prevent these fires, spot them earlier, and fight them more effectively were addressed simultaneously. Cape fire chiefs, state forest fire wardens, and others began to work together to solve these problems. Improvements in machines, equipment, radios, and tactics helped, but it was still the courage and hard work of firemen that put them out. (Centerville-Osterville-Marstons Mills Fire Department collection.)

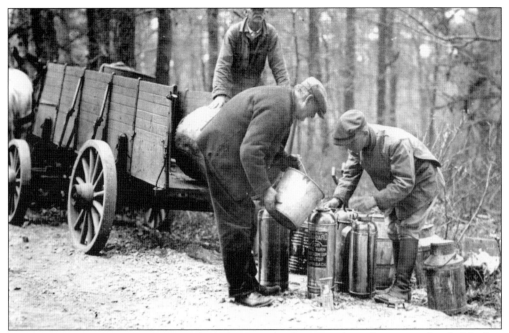

FILLING HAND EXTINGUISHERS. This photograph illustrates how fires were battled before "macheens" were available. The horse-drawn wagon carried buckets of water that would be used to refill hand-held fire extinguishers. This method of fighting fires worked on small fires that could be reached, but it was no match for larger forest fires. (Centerville-Osterville-Marstons Mills Fire Department collection.)

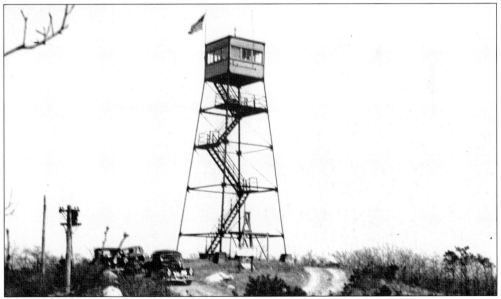

THE FALMOUTH FIRE TOWER. One of the most valuable tools for fighting forest fires was a well-trained "spotter" in a fire tower. This tower, erected in Falmouth in 1914, was typical of the style built in at least seven towns across the Cape. The spotter would use a map in the tower to line up a smoke. By plotting lines from two or more towers, the fire location could be pinpointed and firefighters dispatched. (Falmouth Fire Department collection.)

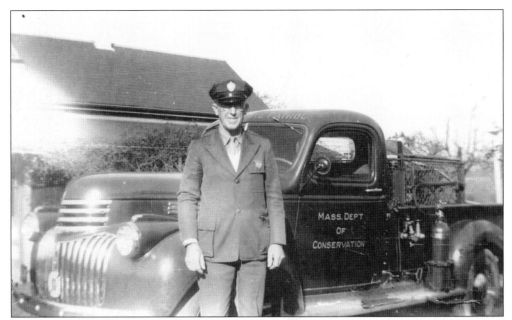

STATE FOREST FIRE PATROLMAN. Henry Perry was the first Cape patrolman for the Massachusetts Department of Conservation. He patrolled the lower Cape from the 1920s to the 1950s. This 1942 Chevy patrol truck carried water, hose, and tools. Some of the first fire radios were installed in patrol trucks and fire towers. Most towns had similar patrol trucks, staffed in the fire season to provide a quick response to fires spotted by the towers. (Walter Dottridge collection.)

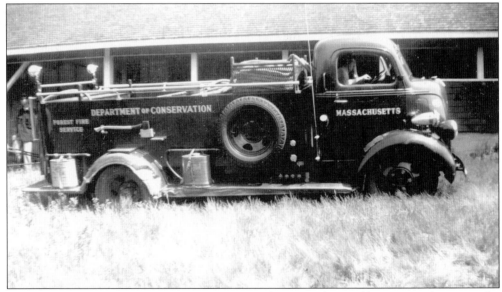

A STATE FOREST FIRE TRUCK. In response to the forest fire problem across the state, the Massachusetts Department of Conservation built a number of these Ford forest fire trucks. They had 250-gallon tanks and power takeoff pumps. Each carried nearly 2,000 feet of forestry hose and a large assortment of tools. This 1939 Ford was initially housed at Bourne headquarters. Eventually, there were several on Cape Cod and the islands protecting the state forests. (Gordon Peters collection.)

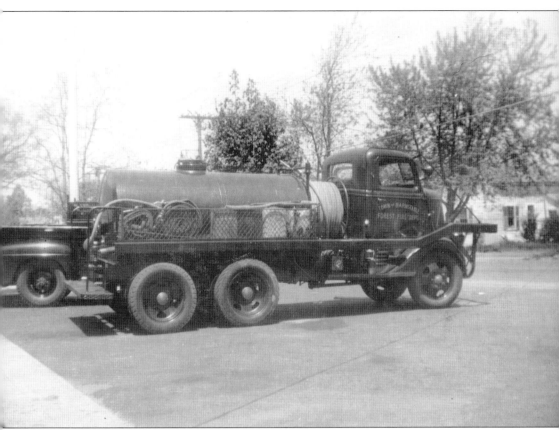

THE FIRST BRUSH BREAKER. One of the most important breakthroughs in fighting forest fires was the invention of the brush breaker. Barnstable fire warden and Centerville-Osterville fire chief Bernard S. Ames, along with Carl Starck and others, built the first breaker at Starck's garage in Osterville in 1937 on a new Ford chassis. Heavy iron bars provided protection and pushing capability. An 800-gallon tank, pump, and hose provided firefighting power. The new truck responded to its first fire on May 5, 1937. It was nearly destroyed when it burned along with 2,000 acres of woods in Hyannis that day. It was rebuilt and served from 1937 to 1952. (Centerville-Osterville-Marstons Mills Fire Department collection.)

THE FIRST BRUSH BREAKER. In 1937, the invention of the brush breaker, with its heavy steel bars, made it possible to fight hard-to-reach fires by driving "through" the woods when necessary. (Centerville-Osterville-Marstons Mills Fire Department collection.)

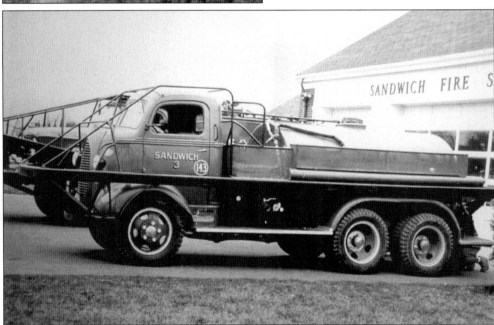

SANDWICH BRUSH BREAKER. Other towns followed Barnstable and built similar brush breakers on a variety of chassis. Sandwich had this breaker built in 1938 by Buffalo Fire Apparatus on a Ford chassis. It had an 85-horsepower V-8 motor and carried 800 gallons of water. It was replaced by a new brush breaker in 1965. (Sandwich Fire Department collection.)

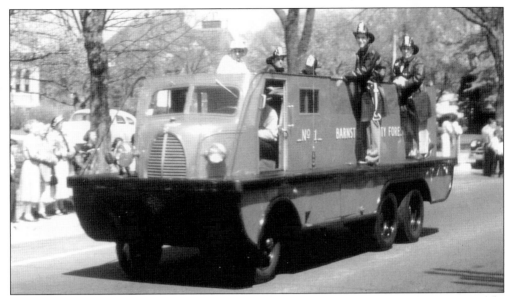

BARNSTABLE COUNTY BRUSH BREAKER NO. 1. The Barnstable County Forest Fire Department built brush breakers between 1939 and 1985. The first county breaker was this 1939 Ford, with Marmon Harrington all-wheel drive, built by Robinson's Boiler Company in Cambridge. It had an 85-horsepower flathead Ford motor and a 125-gallon-per-minute pump. It carried 1,000 gallons of water and had a road speed of 30 to 40 miles per hour. No. 1 was assigned in Falmouth and North Falmouth from 1939 to 1957. (Gordon Peters collection.)

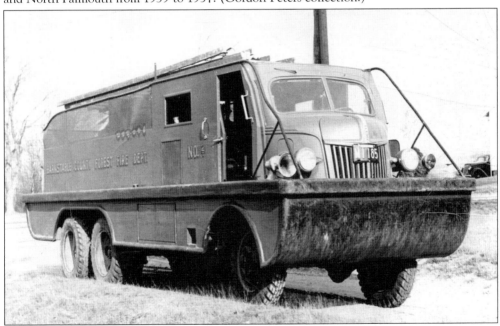

BARNSTABLE COUNTY NO. 2. The second county breaker was built in 1942. It was stationed in West Barnstable from 1942 to 1957, with the exception of a brief assignment in Cotuit. The Mashpee Fire Department bought the 1,000-gallon breaker when the county sold it in 1957. Mashpee operated Breaker 250 from 1957 to 1976, where it earned the proud name of *Geronimo*. (Centerville-Osterville-Marstons Mills Fire Department collection.)

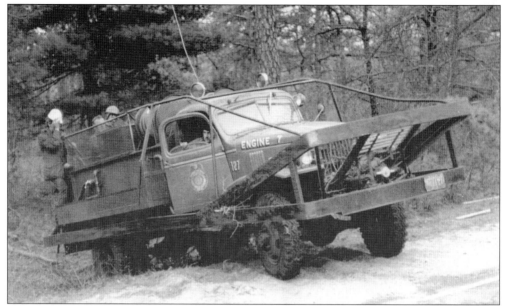

THE BOURNE FIRE DEPARTMENT BREAKER. A number of brush breakers were built on former military chassis. The all-wheel-drive, surplus-military chassis were acquired for less money than a new vehicle and were well suited for the tough demands placed on them. Bourne's 1944 Chevy breaker also had a larger water tank than most engines and would often respond first to structure fires and other incidents. (Bourne Fire Department collection.)

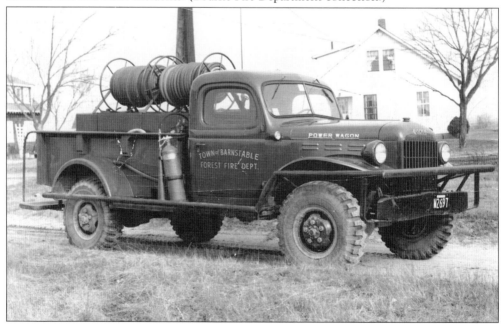

THE COTUIT BREAKER. The Town of Barnstable Forest Fire Department stationed this 1947 Dodge Power Wagon brush breaker in Cotuit for many years. Smaller than many brush breakers, it could sometimes go places the larger breakers could not. This truck served a variety of roles in Cotuit, West Barnstable, and Hyannis. (Centerville-Osterville-Marstons Mills Fire Department collection.)

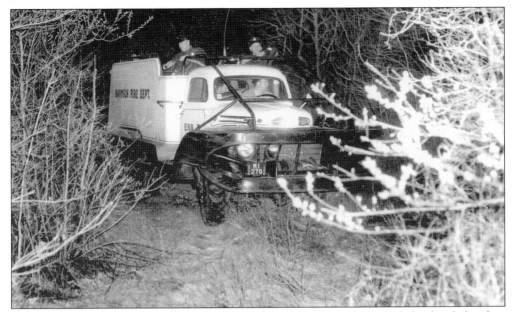

THE HARWICH BRUSH BREAKER. The Harwich Fire Department owned this brush breaker, affectionately known as "the White Elephant." Built by Robinson Boiler on a 1950 Ford Marmon Harrington chassis, it carried 1,500 gallons of water and was one of the largest breakers on the Cape. This breaker, along with others from the Cape, was often sent mutual aid to Plymouth County fires. Breakers work together in teams. (Harwich Fire Department collection.)

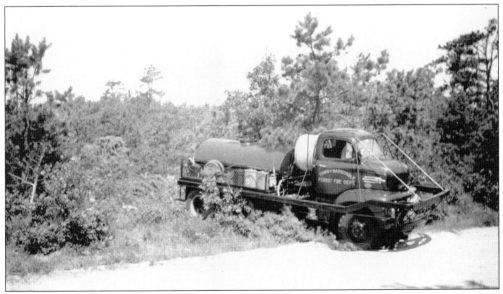

THE NEW OSTERVILLE BREAKER. The first brush breaker, built in 1937, was replaced by this Ford–Marmon Harrington breaker in 1952. The town of Barnstable breaker carried 800 gallons and had a separate motor on the rear to run the pump. The breaker would pump and roll through the woods, as firemen sprayed water from short hose lines on the truck. The large reel behind the cab would be used when hose was dragged into the woods. (Centerville-Osterville-Marstons Mills Fire Department collection.)

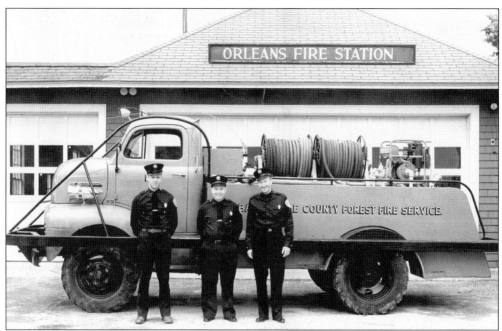

COUNTY BREAKER NO. 3. There were four county breakers on the Cape. Radio C-15 was No. 1 in North Falmouth. C-14 was No. 2 in West Barnstable. C-13 was No. 3 and was housed in Orleans. The 1951 Ford C-13 was smaller than the others, carrying only 600 gallons of water and having only two-wheel drive. C-12 was No. 4 in Dennis. There were about four generations of county breakers: 1939–1942, 1947–1951, 1958–1963, and 1971–1985. (Orleans Fire Department collection.)

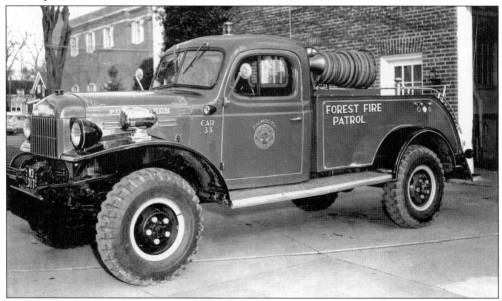

FALMOUTH CAR 33. Dodge Power Wagons were used by some departments for forestry apparatus. Falmouth's 1955 Dodge Car 33 is a good example of these all-wheel-drive, small forestry trucks. Carrying up to a couple hundred gallons of water, they were equipped with forestry hose and had a winch in case they got stuck. (Falmouth Fire Department collection.)

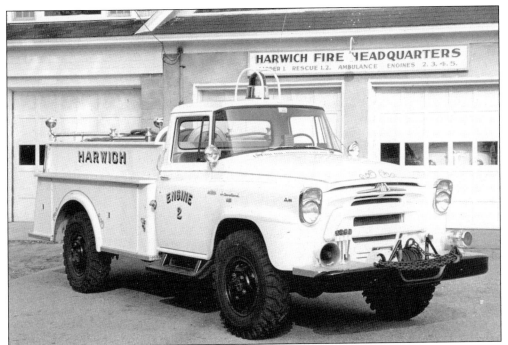

HARWICH ENGINE 2. This 1957 International-Farrar all-wheel-drive truck was used as a forestry engine in Harwich. It also carried a few hundred gallons of water and had a small pump and a winch. Apparatus like this were handy for other incidents as well. Note how Harwich listed its apparatus on the front of the station. (Harwich Fire Department collection.)

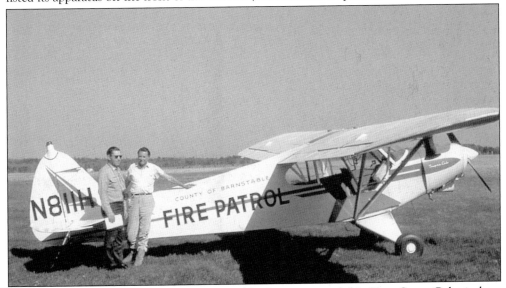

COUNTY FIRE PATROL PLANE P18. Barnstable County owned this Piper Super Cub airplane that served as a fire patrol plane. Fire Warden Robert Dottridge (left) and pilot John Lemos stand by the plane at the Marstons Mills airfield in this *c.* 1960s photograph. P18 relayed important information about the fire to chiefs and could direct brush breakers on the ground into the fire. The eyes in the sky served a major role in the safety of crews on the ground. (Barnstable County photograph.)

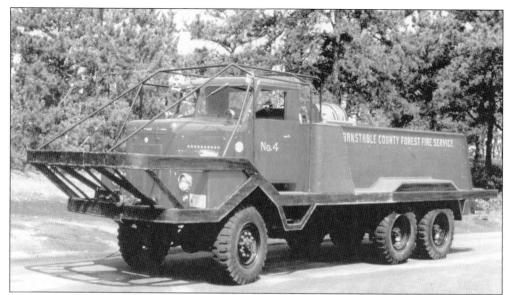

COUNTY BREAKER NO. 4. This 1960 Maxim brush breaker was built by the county and was operated by the Dennis Fire Department for many years. C-12 had an 800-gallon tank. The pump was located in the very back of the truck and was operated by a separate motor. This breaker, later operated by the Brewster Fire Department, went out of service in the 1990s. (Dennis Fire Department collection.)

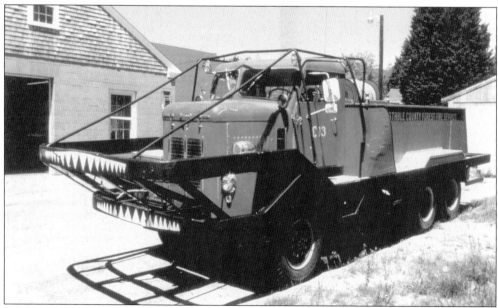

A SMILING BRUSH BREAKER. The Eastham Fire Department owned the old 1963 Maxim Orleans County Brush Breaker C-13 for a period of time in the 1980s. Teeth were painted on the front bars, giving this breaker a big smile. Over the years, smiles similar to this were observed on the faces of many brush breaker drivers as they operated these very special trucks in forests across southeastern Massachusetts. This breaker also ended its career with the Brewster Fire Department in the 1990s. (Crosby photograph.)

Five

RESCUE SQUADS

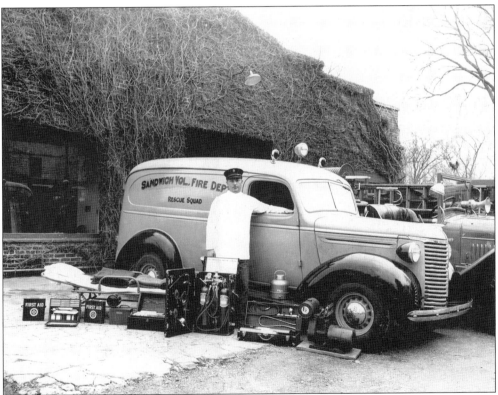

THE SANDWICH VOLUNTEER RESCUE SQUAD. Sandwich bought its first used rescue truck in 1952 from the Barnstable Fire District. The 1935 Chevy panel truck had been custom built by firemen to respond to emergency calls and was used to transport victims to the Cape Cod Hospital. The equipment displayed includes first-aid kits, a stretcher, an oxygen resuscitator, and a generator. "Sandwich Vol." was painted over "Barnstable." This photograph dates from *c.* 1954. (William "Sparky" Donovan collection.)

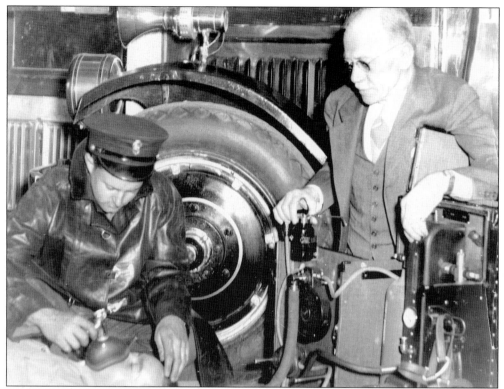

THE HARWICH RESCUE SQUAD. The motto of most fire departments is to "save lives and property." Some fire departments began to form rescue squads in the 1930s. Using some basic equipment, they began to do rescue work at car accidents, drownings, and other emergencies. Community doctors and local Red Cross instructors gave firemen instruction in basic first aid. The ambulance from Cape Cod Hospital in Hyannis transported victims to the hospital. (Harwich Fire Department collection.)

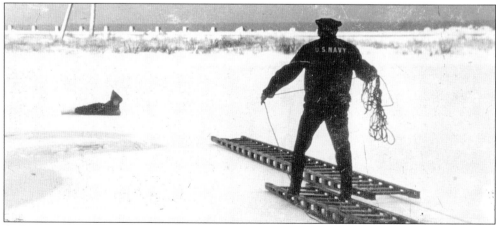

A FALMOUTH ICE RESCUE. Falmouth fire chief Leighton Peck used wooden ladders and a rope to reach a young child who had become trapped on unsafe ice. The fire departments were called for all sorts of emergencies and adapted to the increased demands placed on them. Fire departments bought specialized equipment and attended more training to be better able to serve their communities. (Falmouth Fire Department collection.)

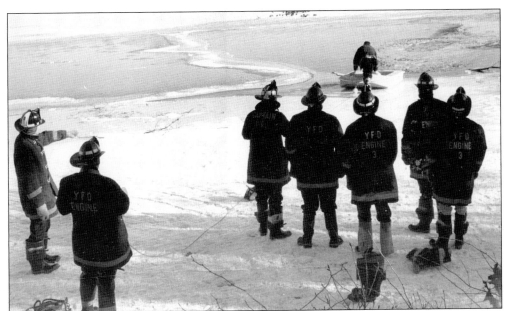

YARMOUTH ICE SLED TRAINING. Training has always been an important part of the fire service. Rescue training must be done in addition to basic firefighter training. In this 1960s view, firefighters from Yarmouth practice ice-rescue techniques with a new fiberglass ice sled. Devices like the ice sled make the job easier and safer for rescuers. (Yarmouth Fire Department collection.)

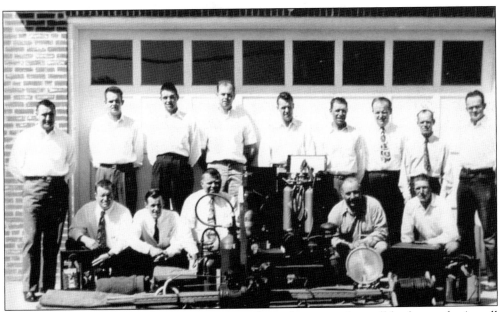

THE OSTERVILLE RESCUE SQUAD. Rescue squad members came from all backgrounds. As call firefighters, they may have been carpenters, plumbers, electricians, mechanics, or businessmen. The common denominator was a strong desire to help their neighbors. Many were very committed to doing rescue work, dropping whatever they were doing, at any time of day, whenever the fire whistle blew. Rescue calls soon began to outnumber fire calls. This photograph was taken *c.* the 1950s. (Centerville-Osterville-Marstons Mills Fire Department collection.)

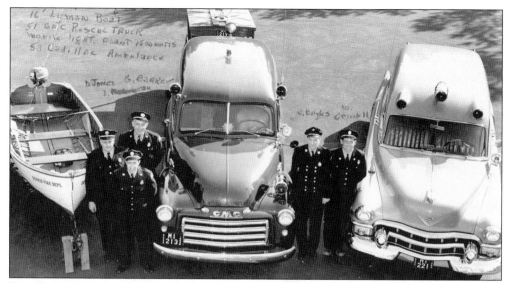

THE DENNIS RESCUE SQUAD. In the 1950s, fire departments began to acquire equipment to meet increasing demands for rescue. Sometimes equipment was bought new. More often, it was acquired secondhand or built by firemen. Here, members of the Dennis squad pose with their 16-foot Lyman rescue boat, the 1951 General Motors rescue truck with mobile lighting plant, and the 1953 Cadillac ambulance. In this *c.* 1955 photograph are, from left to right, David Jones, Leo Babineau, Capt. Gordon Barker, Chief Clarence Bayles, and Lt. Wilbur Grindell. (Dennis Fire Department collection.)

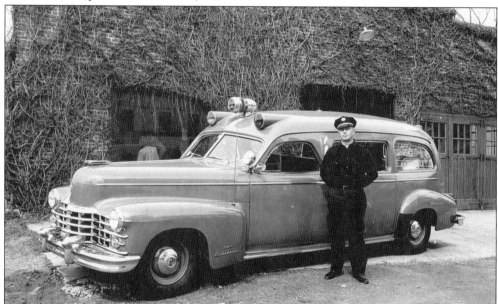

THE SANDWICH VOLUNTEER FIRE DEPARTMENT AMBULANCE. Sandwich bought this 1948 Cadillac Meteor ambulance in April 1954. It was purchased through donations for $2,114. Used in Sandwich from April 1954 to January 1959, it made 339 trips to (or back from) hospitals and rest homes (in the Cape, Boston, and Providence area) at no expense to residents. It was felt that if the service was satisfactory, patients might make a small donation to the ambulance fund. (William "Sparky" Donovan collection.)

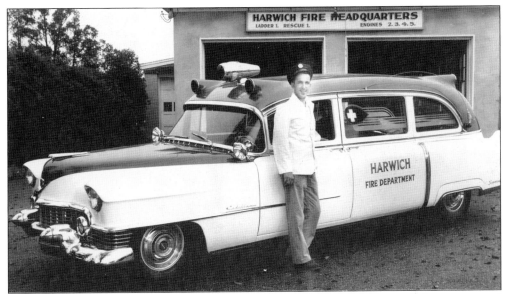

THE HARWICH AMBULANCE. Russell Ritchie poses with this Cadillac ambulance operated by the Harwich Fire Department in the early 1950s. White, with a red roof and hood, this ambulance made the trip to Cape Cod hospital many times. The care provided in those days was the best that could be offered at the time. Rescuers stopped bleeding, splinted broken bones, delivered babies, and did "artificial respirations and heart compressions" when necessary. (Harwich Fire Department collection.)

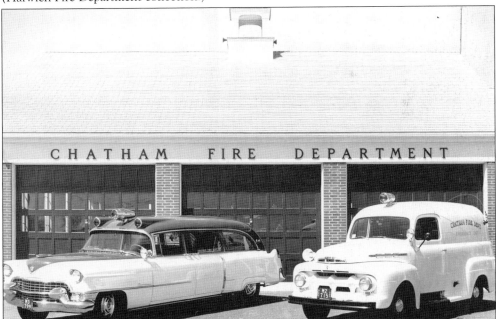

THE CHATHAM RESCUE SQUAD. Panel trucks, such as this 1949 Ford that served as Chatham's first rescue truck, were eventually replaced by Cadillac ambulances or by ambulances built by other manufacturers. The newer ambulances were an improvement over the "homemade" rescue trucks and offered a superior ride for the patients. This Cadillac was a 1955 model. (Chatham Fire Department collection.)

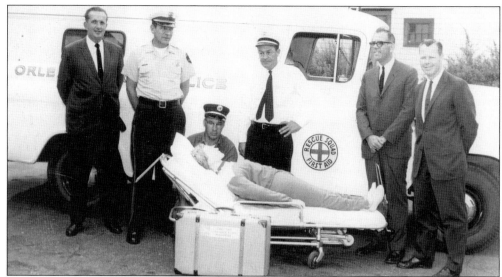

THE ORLEANS RESCUE SQUAD. Cardiopulmonary resuscitation (CPR) was taught to rescuers and the public beginning in the 1960s. An inflatable mannequin named Annie came in a suitcase-size box that could be brought out for training and CPR practice at any time. Civic organizations sometimes purchased these devices and donated them to fire departments. Rescuers used their new rescue skills, and CPR began to save lives that once would have been lost. (Orleans Fire Department collection.)

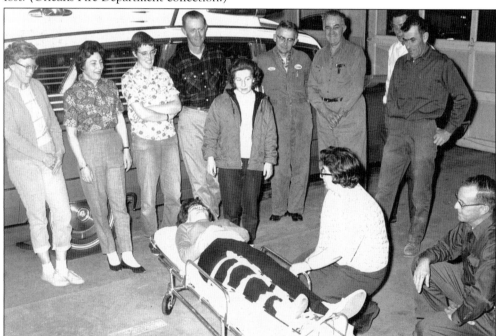

THE SANDWICH WOMEN'S AMBULANCE CORPS. As rescue calls increased, particularly during the daytime, it was sometimes difficult for some men to leave their jobs to go on an ambulance call. In Sandwich, and other towns across Cape Cod, women also joined rescue squads and did whatever they could to help out. Many led the way to improvements by attending training and teaching others. This photograph was taken c. the 1960s. (William "Sparky" Donovan collection.)

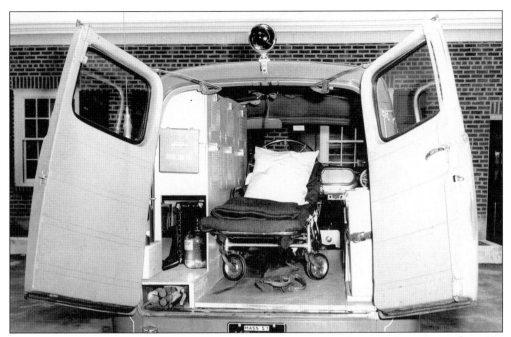

THE HYANNIS RESCUE TRUCK. The Hyannis Fire Department's first rescue truck was this 1954 Dodge panel truck. Rescue squad members constructed the interior of the truck to be able to transport patients with it. A 1956 Cadillac was added in 1959 to meet the increasing demands for ambulance service in Hyannis. (Glenn Cough collection, Hyannis Fire Department.)

THE BREWSTER AMBULANCE. The 1970s saw major improvements in rescue vehicles, equipment, and training. The television show *Emergency* influenced the perception of emergency medicine across the country, and Cape Cod rescue squads were right out front, working together with local doctors and residents to establish the Cape and Islands Emergency Medical Services System (CIEMSS) in the mid-1970s. (Brewster Fire Department collection.)

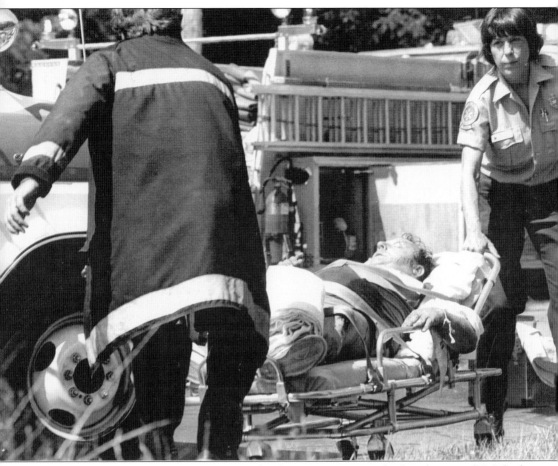

EMERGENCY MEDICAL TECHNICIANS. The first emergency medical technician (EMT) class on Cape Cod graduated 26 students in 1973. The 71-hour standardized class was held at Cape Cod Community College, and select members of area rescue squads were picked to attend. The first graduates were John E. Auston (Eastham), Ivan L. Bassett (Chatham), Robert R. Black Jr. (West Barnstable), Franklin Botelho (Falmouth), Donald B. Burke (Dennis), Charles E. Bunker (Centerville-Osterville), Carmine J. Cotillo (Falmouth), Robert M. Dutra (Falmouth), Stephen P. Edwards (Orleans), Richard R. Farrenkopf (Hyannis), John M. Farrington (Centerville-Osterville), Philip H. Field Jr. (Cotuit), Margot A. Fitsch (Brewster, above right), Stanley A. Gibbs (Bourne), Charles Hamblin (Cotuit), David A. Jones (Barnstable), Lester D. Mason (Hyannis), Charles Mathews (Barnstable), John H. McHugh (Hyannis), Jacque T. McNeight (Yarmouth), Dennis E. Newman (Sandwich), James E. Nichols (Orleans), Peter A. Raiskio (Yarmouth), Arthur J. Sewell Jr. (Dennis), Ronald E. Sgroi (Chatham), and Anthony P. Tassinari (Bourne). By 1975, EMTs were required in all ambulances. Margot Fitsch became the first female firefighter in the state, as well as the first female paramedic. (Brewster Fire Department collection.)

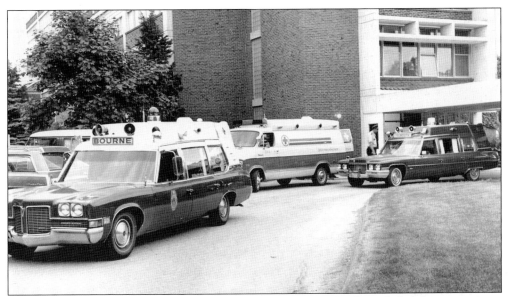

FALMOUTH HOSPITAL. Ambulances from Bourne, Cotuit, and Falmouth fire departments are parked outside the emergency room at Falmouth hospital in the 1970s. As the number of rescue calls increased, departments added permanent firemen and trained them as EMTs. Some days, the ambulance could be out all day, making trips to Cape hospitals or to Boston. The changes in care created a need for larger ambulances, and the Cadillacs began to disappear. (Falmouth Fire Department collection.)

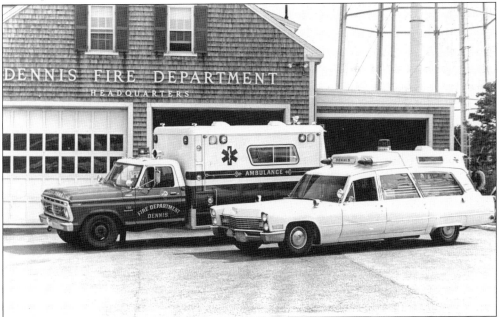

DENNIS RESCUE. As Cadillac ambulances were replaced, fire departments opted for van-style and box-style ambulances. These vehicles were able to carry more equipment and had more room to provide specialized emergency procedures while transporting patients to the hospital. Radios in the back enabled the EMTs and paramedics to talk directly with the hospital. This picture was taken *c.* 1973. (Dennis Fire Department collection.)

CAPE PARAMEDICS. A grant from the Robert Wood Johnson Foundation led to the development in 1976 of an emergency radio communications system and the training of the first paramedics in Massachusetts. New lifesaving equipment, such as the Lifepak 4 and Lifepak 5 defibrillators, were purchased through donations and fundraising efforts. Centerville-Osterville firefighters Craig Whiteley (left) and Philip H. Field Jr. (right) were graduates of Paramedic Class I. (Centerville-Osterville-Marstons Mills Fire Department collection.)

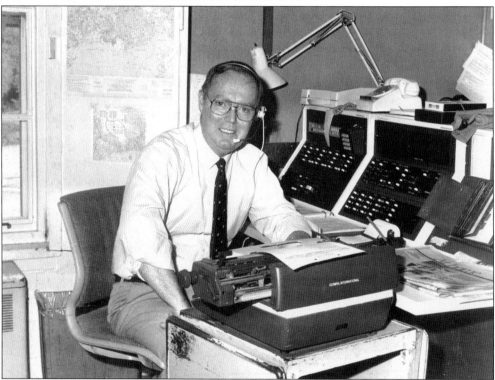

CMED RADIO. Communication is an important part of emergency medical service. It allows paramedics to speak directly with doctors in the emergency rooms. The hub of this system is CMED, located at the Barnstable Sheriff's Department radio room at "the shack." In the 1970s, John Loughnane was one of the dispatchers at KAG 416, the Barnstable CMED. (Barnstable County collection.)

Six

FIRES AND DISASTERS

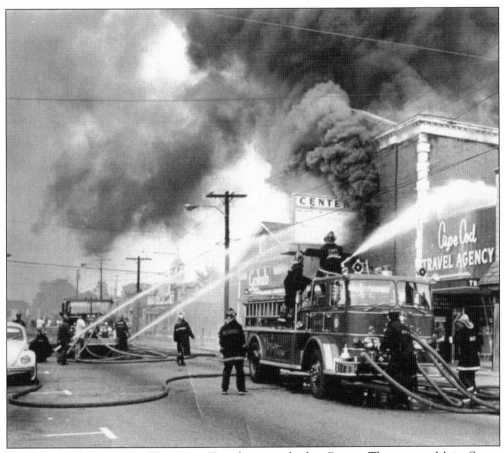

THE CENTER THEATER, HYANNIS. Two fires struck the Center Theater on Main Street in Hyannis. The first, in December 1971, damaged and closed the theater. The second fire (shown here), on July 2, 1972, destroyed the Main Street landmark in a spectacular fire that brought mutual aid from several towns. Hyannis Engines 6 and 2 are shown operating. (Gordon Caldwell photograph.)

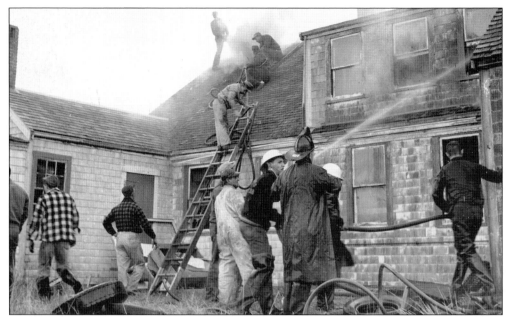

A 1950s Orleans House Fire. Firefighting on Cape Cod was done almost exclusively by volunteer and call firefighters for many years. Men would show up from the job site wearing whatever they had on and would begin to fight the fire. Protective equipment, such as helmets and rubber coats and boots, were not always available. Fires were often fought from the outside. Some departments had a couple of Scott packs (breathing apparatus), but not enough to go around. (Orleans Fire Department collection.)

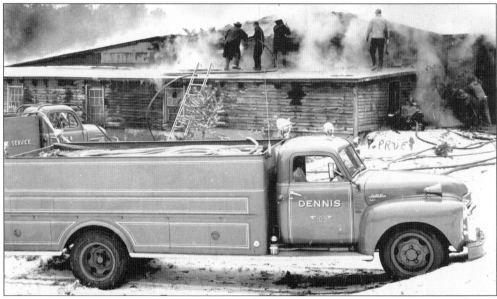

A Dennis Port Fire. Dennis firefighters battle a stubborn blaze in Dennis Port in the 1950s. There were many causes of fires. Some were accidental and were caused by candles, lamps, kerosene heaters, electrical wiring, and carelessly discarded cigarettes (perhaps the most common cause). Other fires were intentionally set with a variety of motives. Fire departments responded to many fires from the 1950s to the 1980s. (Dennis Fire Department collection.)

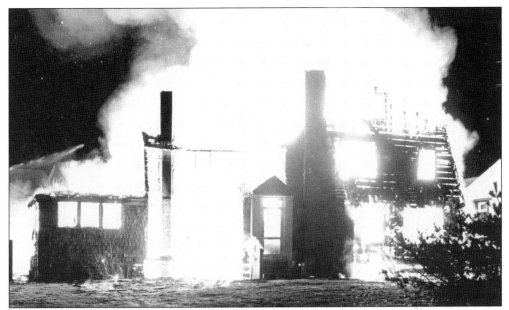

CHASE AVENUE, DENNIS PORT. Dennis firefighters arrived at this fire in Dennis Port on February 11, 1969, just before 11 p.m. This "fully involved" fire could be seen from a great distance at night. The radiant heat from this fire threatened nearby buildings. Brands and sparks, pushed high into the air, could set fires in the woods or on roofs of other buildings. (Dennis Fire Department collection.)

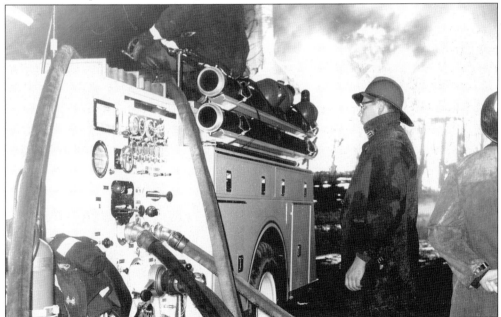

HARWICH ENGINE 1 PUMPING. In this 1960s view, Harwich firefighter Peter Norgeot runs the pump on the Harwich Fire Department's 1964 Maxim Engine 1. The pump operator did not have the most glorious job at fires but was responsible for getting water and for providing the right pressure to each hose line, often under stressful conditions. A good pump operator was, and still is, worth his weight in gold. (Harwich Fire Department collection.)

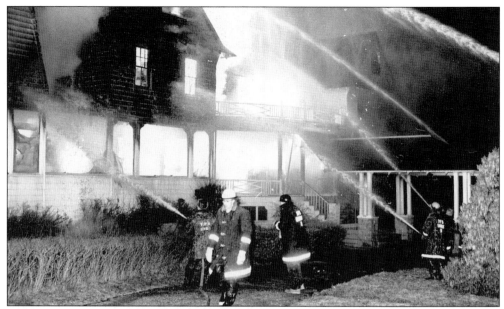

THE ENGLEWOOD HOTEL, WEST YARMOUTH. Some fires stand out in history above others. The large Englewood Hotel fire, on January 10, 1962, was one of the "big ones" that is still talked about today. Bitter cold temperatures and plenty of fire faced firefighters from many communities as they worked through the night with Yarmouth firefighters. (Yarmouth Fire Department collection.)

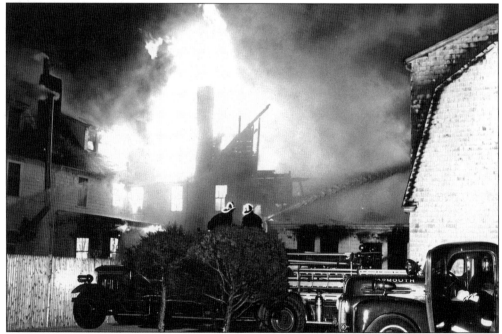

THE ENGLEWOOD HOTEL. Firefighters on the Hyannis ladder truck operate a deck gun into the rear of the building. Yarmouth Engine 3 drafted from a swimming pool. Hyannis firefighters are easily recognized by the reflective treatment on their helmets. (Yarmouth Fire Department collection.)

THE WOOD LUMBER COMPANY, FALMOUTH. Another "big one" was the general alarm fire that consumed the Wood Lumber Company in Falmouth in 1963. Here, members of Falmouth Ladder 2 operate a deck gun onto the fire. Mutual aid came from many surrounding communities, and thousands of feet of hose were used to fight the fire. (Falmouth Fire Department collection.)

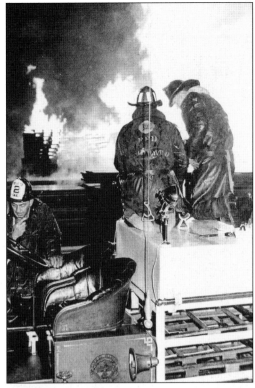

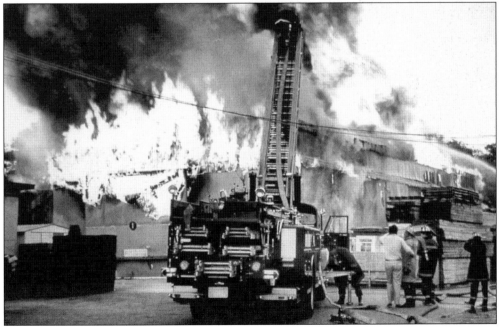

THE FALMOUTH LUMBER FIRE. The Falmouth Fire Department's 1969 American LaFrance 100-foot aerial Ladder 1 got a lot of work in its career. Here, it sets up its ladder pipe at another lumberyard fire, at Falmouth Lumber on Route 28 in Teaticket on July 4, 1976. (Falmouth Fire Department collection.)

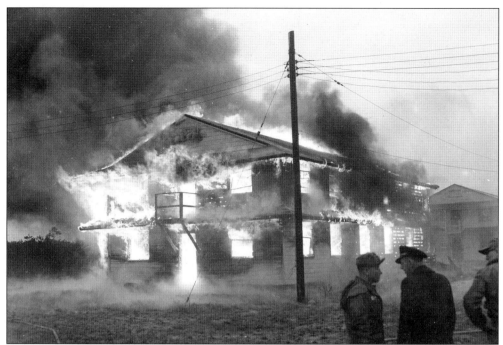

OTIS AIR FORCE BASE. The base built a lot of barracks like this one to house troops there during the 1950s and 1960s. Construction was nothing fancy, and when a fire did get started, it would burn with great intensity. These buildings were close together, and firefighters had to work aggressively to keep fires from spreading. Fire prevention became a priority on the base because of fires like this. (Calvin Hitchcock collection.)

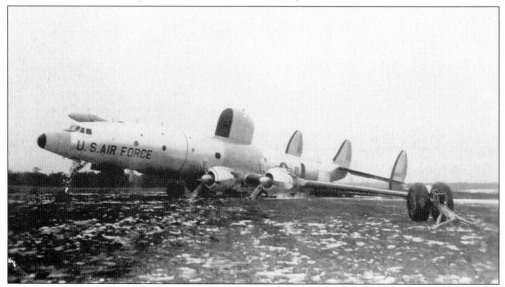

OTIS AIR FORCE BASE. Otis was at one time the largest air defense base in the world. It was home to two fighter squads, SAC fuel aircraft, a BOMARC missile site, and 35 of these EC-121 Super Constellation aircraft. Otis responded to a lot of incidents on and off the base involving base aircraft. A number of jets went down in surrounding towns, resulting in large flammable fuel and forest fires. (Calvin Hitchcock collection.)

A 1960s HYANNIS HOUSE FIRE. While fires in commercial buildings were often more spectacular, fires in houses were far more common. Here, Hyannis firefighters try to put out a bedroom fire on the second floor. Lt. Richard Donoghue (on the ladder) was one of the permanent men in Hyannis. He was killed in the line of duty in 1967 when a ladder came in contact with high-voltage wires. (Hyannis Fire Department collection.)

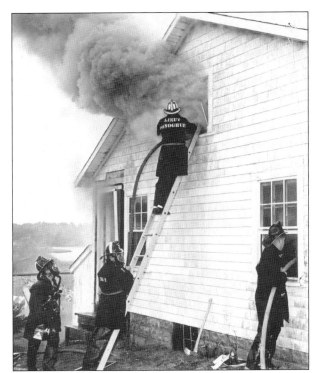

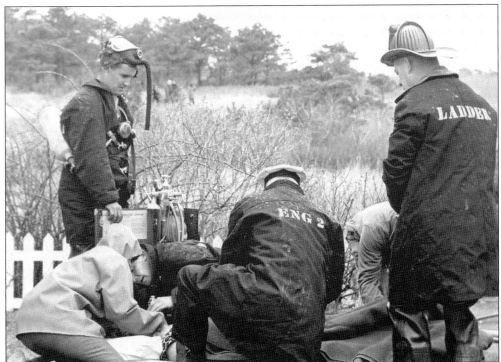

THE HYANNIS HOUSE FIRE. A woman was rescued from the house fire on Ocean Street. Here, Hyannis firefighters give her oxygen. They are David Jones (left), Chief Glenn Clough (center), and Norm Merritt. (Hyannis Fire Department collection.)

THE OYSTER HARBORS CLUB. The Oyster Harbors Club, in Osterville, was an example of some of the large hotels that were built in towns across the Cape. These large hotels catered to summer visitors but, in many cases, were not built for year-round use, nor was there a need for that. Many of these large hotels burned down, or were torn down to build more efficient buildings. When the club was being torn down on January 19, 1968, it caught fire. (Crosby collection.)

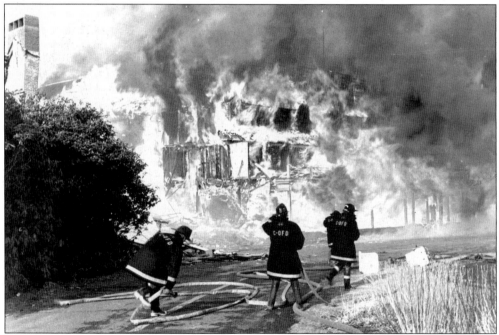

THE OYSTER HARBORS CLUB. During the Oyster Harbors Club blaze, a strong wind quickly pushed the fire through the open building, and this is what firefighters found on arrival. Despite the efforts of firefighters from several communities, the building was reduced to smoldering ruins in a matter of hours. (Centerville-Osterville-Marstons Mills Fire Department collection.)

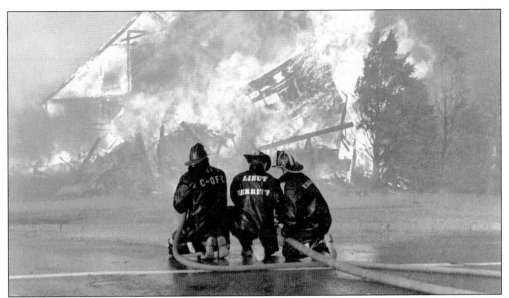

THE OYSTER HARBORS CLUB. Large fires like the one at the Oyster Harbors Club require a great deal of assistance to extinguish. Fire departments make mutual-aid agreements with each other for incidents of this size. Response is of no cost to the community requesting aid, as long as that department mutually agrees to return the favor. The Yarmouth Fire Department KCD 246 coordinated requests for help as the mutual-aid center. (Centerville-Osterville-Marstons Mills Fire Department collection.)

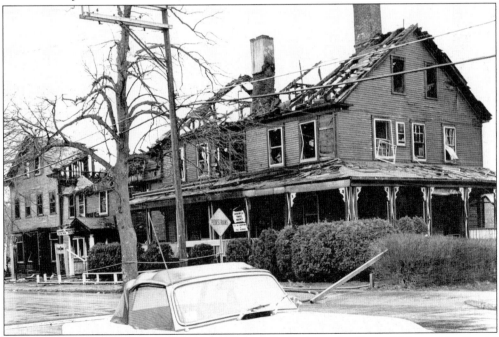

THE DANIEL WEBSTER INN, SANDWICH. Originally built as the Central House, the Daniel Webster Inn was a landmark on Main Street in Sandwich. Firefighters from at least 10 communities with more than 20 pieces of apparatus responded to the general alarm fire that destroyed it on the night on April 22, 1971. (Hyannis Fire Department collection.)

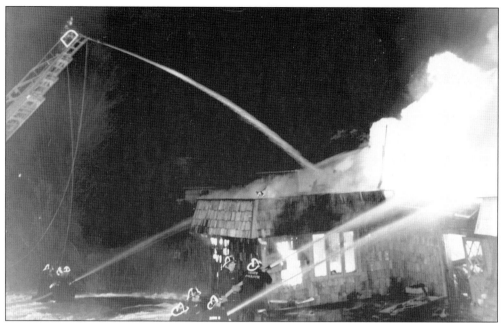

THE OLD HARBOR CANDLE FACTORY, HYANNIS PORT. In another spectacular fire, the Old Harbor Candle Factory in Hyannis Port burned on March 8, 1969. The Hyannis ladder truck's ladder pipe was used to quell flames from above, while many hose lines were being used by firefighters from several departments assisting Hyannis. (Hyannis Fire Department collection.)

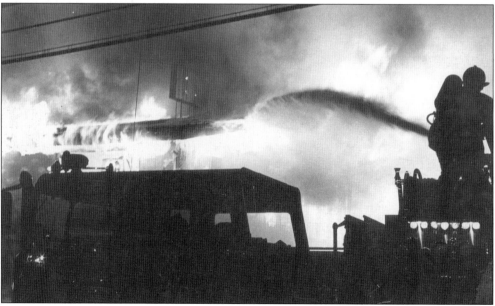

A WEST YARMOUTH FIRE. A Yarmouth firefighter operates a deck gun at a large fire on Route 28 in West Yarmouth in the late 1970s. The ability to fight fires like this one improved as more powerful apparatus and equipment—coupled with larger-diameter hoses, better protective equipment, and improved training—became more prevalent. Smoke detector laws and stricter building codes have helped reduce the number of these big fires. (Yarmouth Fire Department collection.)

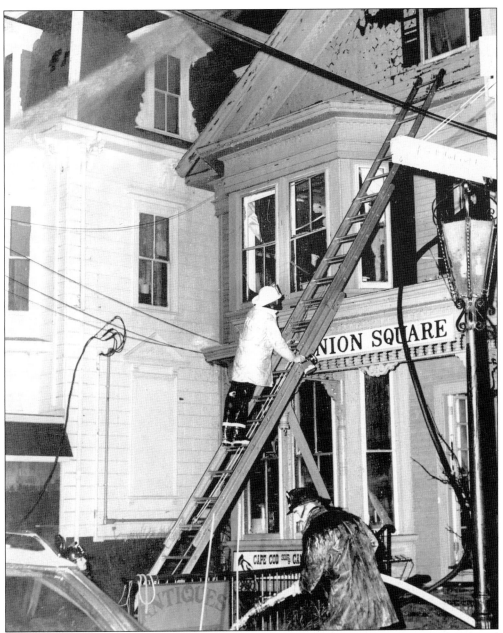

PROVINCETOWN. A Provincetown district chief gets a closer look at operations on the second floor of the Union Square building on Commercial Street at a fire in the 1970s. Fighting fires in Provincetown is no easy job. The volunteer department must deal with fires in large wooden buildings like these, built very close to each other. Cars parked on narrow streets can block fire apparatus. Summer crowds, extreme weather conditions, and a host of other factors are added to already bad conditions at any given fire. Because Provincetown is at the tip of the Cape, it can take a long time for help to arrive. Over the years, many huge fires have threatened to cause a conflagration in this town. Working against great odds, the initial efforts of the Provincetown department, with the help of departments from across the Cape, have kept many fires from burning down the town. (Provincetown Fire Department collection.)

A 1960s Provincetown Wharf Fire. At one time, the inner harbor of Provincetown was lined with large wooden wharfs. Several hundred feet long, some wharfs were themselves little self-sufficient communities. Fighting fires at the end of these wharfs was extremely dangerous. Pumpers drafted saltwater from the harbor as firefighters, able to access the building from only one side, attempted to control the fire. (Provincetown Fire Department collection.)

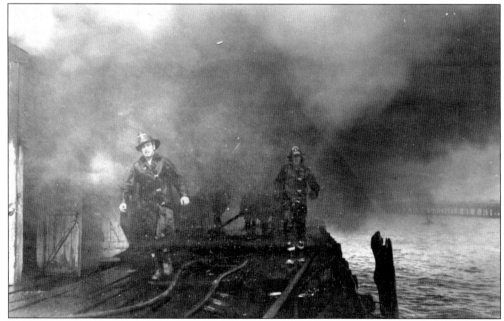

The Provincetown Wharf. The battle to save these wharfs was often in vain. The old wooden wharfs had very little protection from fire, and winds from any direction would hamper the efforts of firefighters. With no breathing apparatus, limited access, a lack of effective hose streams, and the ever-present danger of falling overboard, these were some of the most dangerous fires to fight. (Provincetown Fire Department collection.)

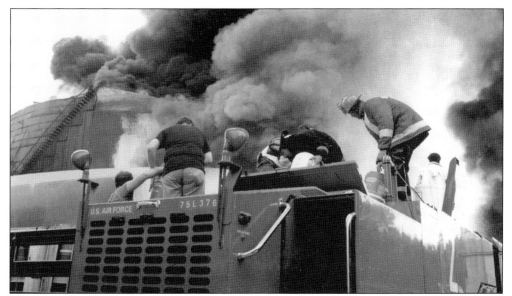

THE CANAL ELECTRIC FIRE. One of the largest and most memorable fires in recent years was at the Canal Electric power plant on the Cape Cod Canal in Sandwich on "Torrid Tuesday," August 5, 1980. Temperatures were already in the 90s when the fire began at 9:32 a.m. A large steel storage tank containing over five million gallons of No. 6 fuel ignited. Mutual aid responded from 32 fire departments. Here, firefighters add foam to the Otis Fire Department crash truck. (Calvin Hitchcock collection.)

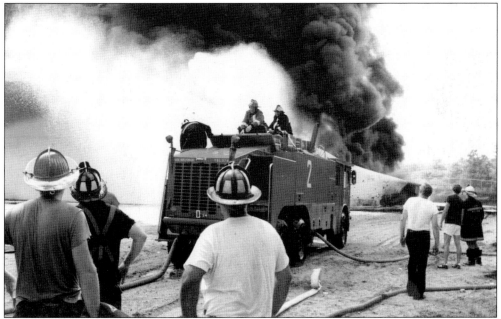

CANAL ELECTRIC. It was estimated that the fire would take at least 12 hours to control. It was controlled in half that time through the exhaustive efforts of 250 firefighters, using 27 engines, 7 ladders, and dozens of other vehicles. Over 1,800 gallons of foam concentrate and 100,000 gallons of saltwater from the canal was used. It was one of the largest mutual-aid responses in Cape history. (Calvin Hitchcock collection.)

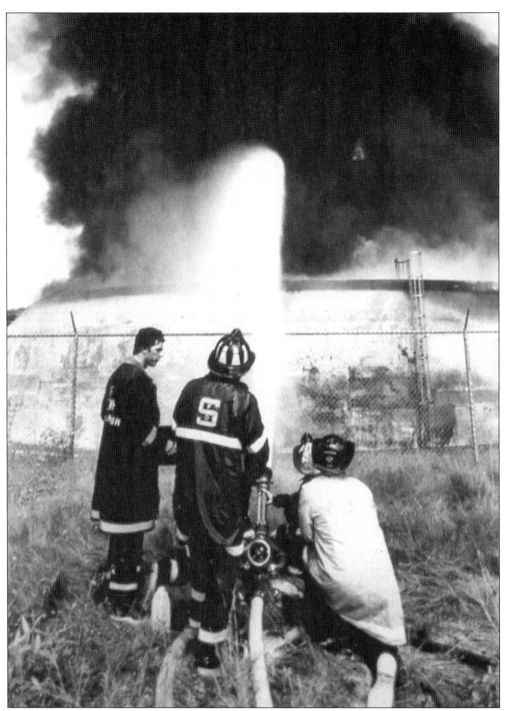

CANAL ELECTRIC. Fires like the August 1980 Canal Electric blaze are very dangerous. The training and experience of chiefs, officers, and firefighters are important factors in putting such fires out without anyone being seriously hurt. It is a credit to them that only a few minor injuries and heat exhaustion problems occurred at this massive team effort that day. (Sandwich Fire Department collection.)

Seven

FIREFIGHTERS

SANDWICH FIREFIGHTERS. Firefighting is a team sport. It is made up of individuals with different backgrounds and experiences. Together, under the leadership of their officers, they are able to accomplish great things. These guys are pictured fighting the biggest fire of their careers at the Canal Electric plant on that hot Tuesday morning in August 1980. This is what it is all about. (Sandwich Fire Department collection.)

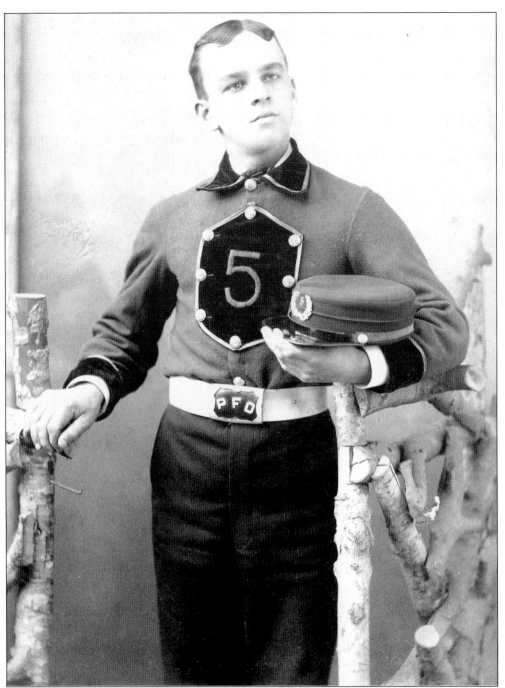

A PROVINCETOWN FIREMAN. Provincetown's Tiger No. 5 engine company was organized in 1873. Using the apparatus of the old Franklin No. 2 (1850), the new company was made up of some 50 grammar and high school boys (ages 14–18) who got their fire education with Tiger Company. The pride of this young man, posing c. 1886 in his uniform complete with leather parade belt and hat, is clear. Generations of families have served fire departments by involving their youths in the community fire department. (Provincetown Fire Department collection.)

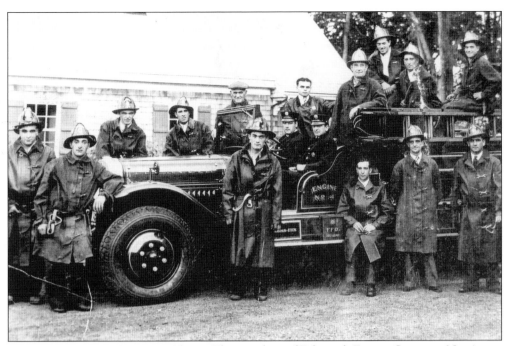

FALMOUTH ENGINE COMPANY NO. 4. The members of Falmouth Engine Company No. 4 pose with their 1930 Ahrens Fox pumper. Engine 4 was originally in East Falmouth but was moved to West Falmouth when that station opened. Departments like Falmouth operated for many years with a combination of permanent firemen and call firemen working together. (Falmouth Fire Department collection.)

PROVINCETOWN PUMPER NO. 1. Provincetown's volunteer department, shown in the 1950s, was unique in many ways. Each of the companies operated out of its own firehouse. Firemen had a healthy amount of pride in their company, and great competition existed among companies. The ability to turn out quickest and get water on the fire first was important not only to fighting the fires but also to the social atmosphere that held the department together when there were no fires. (Provincetown Fire Department collection.)

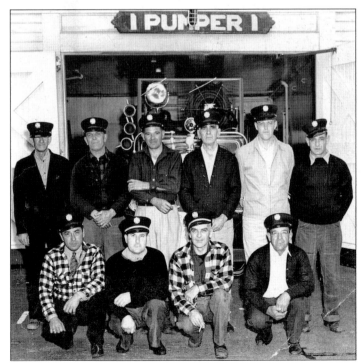

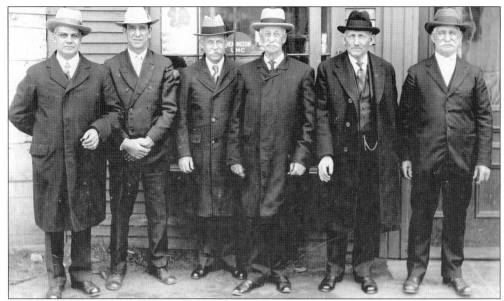

THE 1928 PROVINCETOWN BOARD OF ENGINEERS. The leadership of departments like Provincetown was the responsibility of an elected or appointed board of engineers. These men created and enforced department policy and served as chiefs, district chiefs, and deputies in their districts. From left to right are Thomas J. Lopes, John J. Leonard, Louis A. Law, Fire Chief James H. Barnett, T. Julian Lewis, and James E. Callaghan. Barnett was chief for more than 30 years. (Provincetown Fire Department collection.)

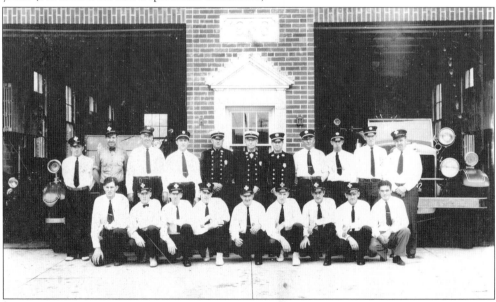

THE BOURNE FIRE DEPARTMENT. Members of Bourne Company No. 1 pose in front of the Buzzards Bay station in 1936. From left to right are the following: (front row) Harold Haskell, George Palmer, Charles Westgate, A. Barbeau, Earnie Harris, Harry Robins, Frank Griswald, Ben R. Jones, and Eugene Barbeau; (back row) Jerry Perry, James Kerr, Ed Westgate, Arthur Harns, J. Wallace, James Taylor, Leo Bachard, Milton Henly, Al Johnson, Nat Burgess, and Rod McKenzie.

BOURNE CHIEF THOMAS WALLACE. The head of the fire department is the fire chief. A lot of responsibility falls upon his shoulders. On duty 24 hours a day, every day, the chief responds to all kinds of fires and emergencies. Often arriving before the apparatus, the chief would command the fire and sometimes even put it out before the guys got there. Shown in the 1950s, this imposing car is a Kaiser. (Bourne Fire Department collection.)

THE FALMOUTH FIRE DEPARTMENT. In this 1950s view, Chief Leighton "Pat" Peck (right) and Tom Manchester stand in the alarm room at Falmouth headquarters. Chief Peck served as Falmouth's fire chief from 1956 to 1976. (Falmouth Fire Department collection.)

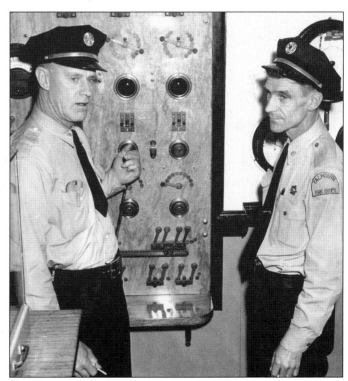

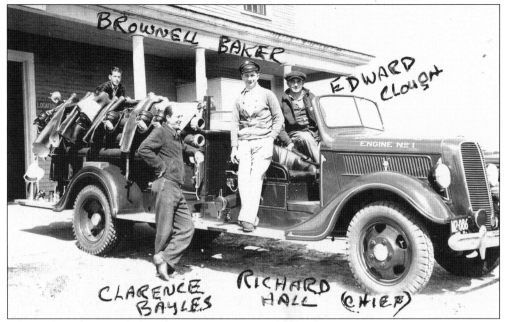

THE DENNIS FIRE DEPARTMENT. Members of the Dennis Fire Department pose with Engine 1 in front of the South Dennis fire station. Engine 1 was a 1937 Ford 500-gallon-per-minute pumper. From left to right are Brownsell Baker, Clarence Bayles (future chief), Chief Richard Hall, and Edward Clough (future chief). (Dennis Fire Department collection.)

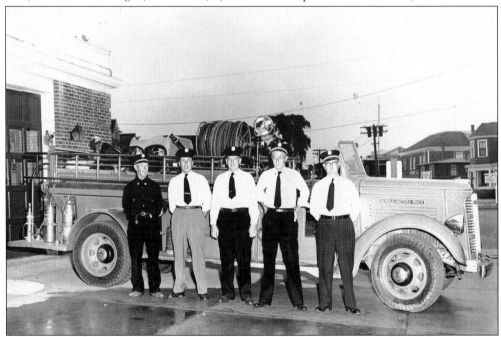

HYANNIS ENGINE 3. Members of the Hyannis Port crew pose in the 1950s with their 1937 General Motors Engine 3 in front of the Barnstable Road headquarters. They are, from left to right, Assistant Chief George Sturges, John McHugh, Capt. Guy Brightman, Richard Sturges, and Joseph Kelly. (John McHugh collection.)

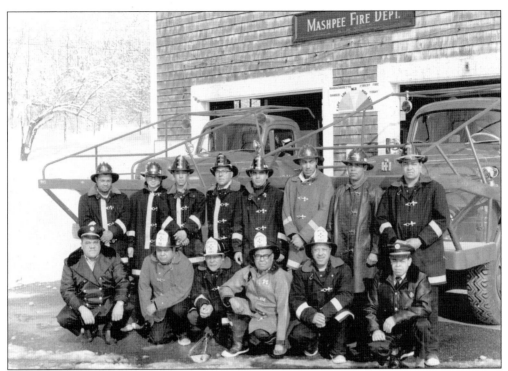

THE MASHPEE FIRE DEPARTMENT. Chief Ellsworth F. Peters (front left) and his two sons, Gordon (lieutenant, next to chief) and Edward (deputy chief, front right), pose with other members of the Mashpee Fire Department in front of the station in 1967. Engine 1 was a 1957 International-Maynard brush breaker. Engine 4 was a 1967 International-Thibault brush breaker. Peters was chief from 1950 to 1968. (Gordon Peters collection.)

THE CHATHAM FIRE DEPARTMENT. Shown in 1937 are, from left to right, the following: (front row) Elmer B. Sampson, Tyler Atwood, Weston Nickerson, Willard Nicholas, D. Elmer Howes, Elisha H. Bearse III, Wilbur Cahoon, and Chief George Goodspeed Sr.; (middle row) Frank Dill, Parker Romkey, Merril Doane, Victor Chase, and Walden Bearse; (back row) Joseph C. Eldredge, Zenas Kendrick, Ernest Eldredge, Clement Eldredge, Edwin Eldredge, Robert Tuttle, Cyrus Baker, Albert Young, Charles Cahoon, Rodney Eldredge, and Cyril Cahoon. (Chatham Fire Department collection.)

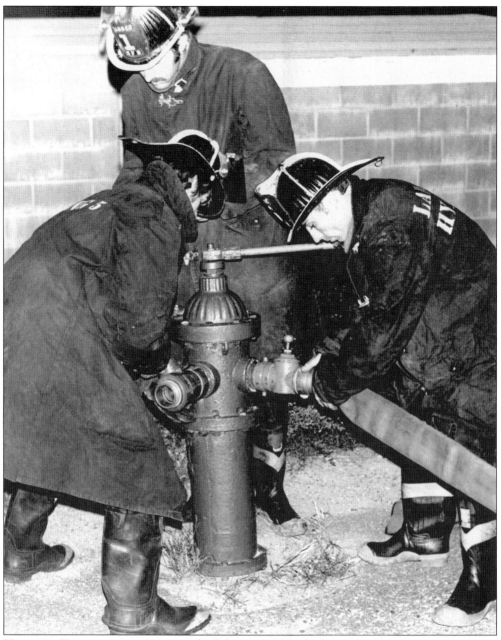

HYANNIS FIREFIGHTERS. Hyannis firefighters dress a hydrant during a training exercise in the 1970s. Thousands of firemen have served Cape departments over the years. Not all of their names are known. Most were never captured on film. Some played major roles in their departments, while others did much less. All of them have been important, and their contributions made a difference in many ways. (Hyannis Fire Department collection.)

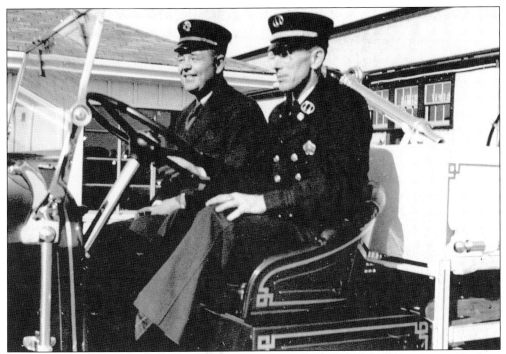

THE FALMOUTH FIRE DEPARTMENT. Two members of the Falmouth Fire Department drive Falmouth's 1938 Maxim Ladder 2 in a parade in the 1950s. (Falmouth Fire Department collection.)

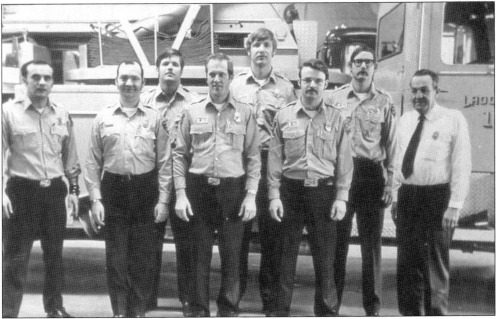

THE ORLEANS FIRE DEPARTMENT. Some of the original permanent firefighters in Orleans pose in front of their 1974 Maxim ladder truck in the 1970s. From left to right are Capt. Raphael Merrill, Paul Nichols, Lt. Paul Tassi, Lt. Sonny Reed, Clayton Reynard, Lt. Steven Edwards, Richard Harris, and Chief Lawrence L. Ellis. Both Merrill and Edwards later served as chief. (Orleans Fire Department collection.)

HARWICH CAPTAIN BILL FRATUS. There have been many characters in the fire departments on Cape Cod, too many to mention here. Some, such as Bill Fratus (pictured in the 1950s), liked to tinker with things. The opportunity to fix something or to make something was always there. Others liked to play jokes, tell stories, or play a game of cards. Some were quiet, while others were just the opposite. Some studied and taught, while still others just did what was asked of them. It was a wonderful mix that made life around the fire stations interesting. (Harwich Fire Department collection.)

Eight

MODERNIZATION

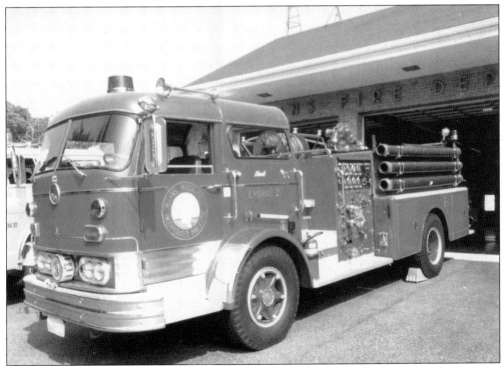

ORLEANS ENGINE 1. The first diesel pumper on Cape Cod was this 1966 Mack C pumper in Orleans. It had a 1,000-gallon-per-minute pump and a 500-gallon tank. The modernization of Cape Cod's fire departments occurred over a period of years as older apparatus was replaced with newer apparatus. Enclosed cabs, more powerful motors, larger pumps, larger water tanks, and safer, more reliable apparatus became the norm during the 1960s and 1970s. (Crosby photograph.)

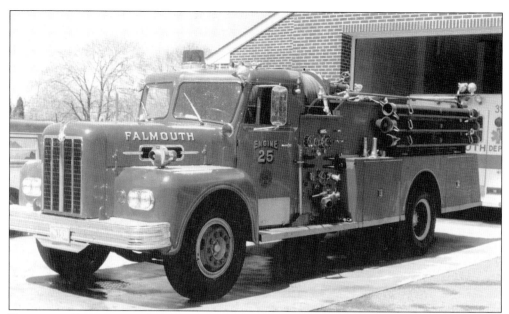

FALMOUTH ENGINE 25. The Falmouth Fire Department used Maxim apparatus for decades. A new generation of Maxims joined the force between 1960 and 1963. Engines 2, 4, and 5 were all Maxim S models. Engine 2 in Woods Hole and Engine 4 in West Falmouth had open cabs, while Engine 5, the last delivered, had an enclosed cab. Each fought many fires between the 1960s and late 1980s. (Gordon Peters collection.)

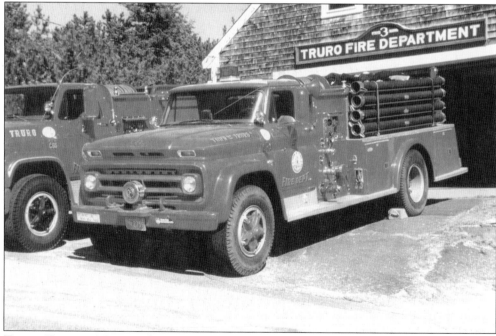

TRURO ENGINE 5. Maynard Fire Apparatus in Marshfield built this pumper for the Truro Fire Department in 1964. Built on a Chevy commercial chassis, it had a 750-gallon-per-minute Darley pump and carried 800 gallons of water. It was one of a number of Maynard apparatus on the Cape. (Crosby photograph.)

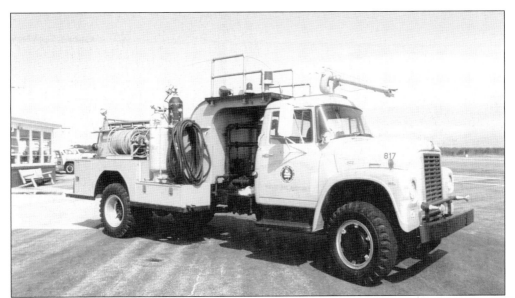

BARNSTABLE MUNICIPAL AIRPORT. The main commercial airport on the Cape is Barnstable Municipal Airport in Hyannis. This airport crash truck was built on a 1964 International four-by-four chassis. The body came off the older crash truck built by Maxim. It had a 500-gallon tank, foam, and chemicals and could be operated by one man until help arrived from the Hyannis fire department. (Crosby photograph.)

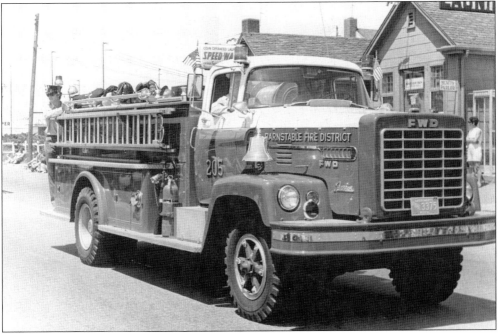

BARNSTABLE ENGINE 205. The Barnstable Fire District bought this all-wheel-drive FWD-Farrar 750-gallon-per-minute pumper in 1965. It carried 500 gallons of water and a standard assortment of hoses and tools. The prominent grill on this engine made it easily recognizable. Shown *c.* 1972, this engine served the Barnstable Fire Department until 1996. (Hyannis Fire Department collection.)

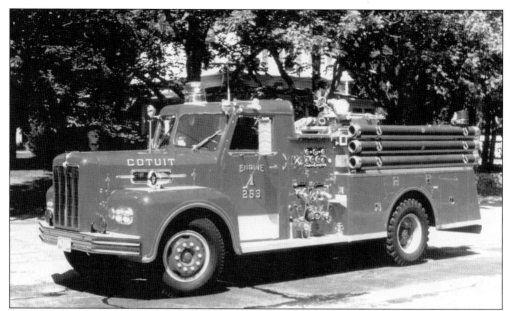

COTUIT FIRE DISTRICT ENGINE 1. Another of Maxim Motors deliveries to the Cape was this 1966 S model for the Cotuit Fire District. The 1,000-gallon-per-minute 500-gallon pumper served as Engine 1. The number 263 was used on the radio for mutual-aid purposes. All apparatus had specific numbers assigned for the mutual-aid radio channel. Cotuit bought an International-Maxim for Engine 2 in 1970. (Crosby collection.)

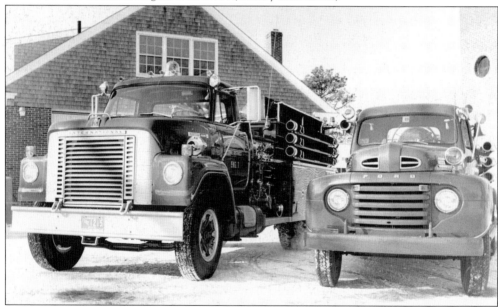

CENTERVILLE-OSTERVILLE ENGINE 1. Centerville-Osterville replaced its 1950 Ford-Maxim Engine 1 with a 1969 International-Maxim 1,000-gallon-per-minute pumper. The new pumper carried 500 gallons of water and was able to carry much more equipment in compartments. A similar purchase in 1968 replaced Engine 2. The 1968 and 1969 International pumpers remained part of the Centerville-Osterville fleet through the 1990s. (Centerville-Osterville-Marstons Mills Fire Department collection.)

112

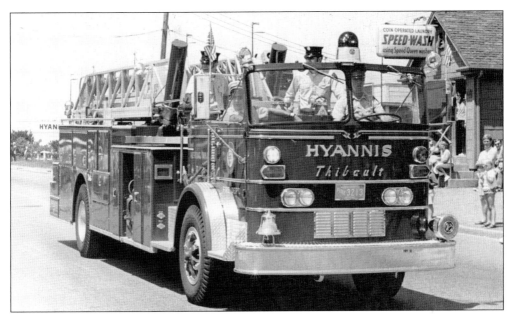

HYANNIS LADDER 1 (89). Only the second aerial ladder ever on Cape Cod (Falmouth bought the first in 1949), this 1968 Thibault 85-foot aerial ladder truck served the Hyannis Fire District from 1968 to 1994. Built in Canada, it had one of the strongest ladders made. The cab was enclosed and a 100-foot aerial was added in a 1980s refurbishing. This photograph was taken *c.* 1972. (Hyannis Fire Department collection.)

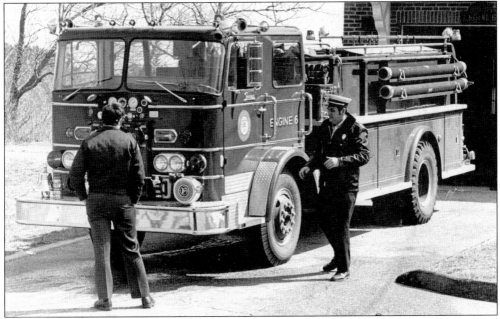

HYANNIS ENGINE 6 (86). The Hyannis Fire District operated a number of front-mount pumpers over the years. The trend continued when modern engines were bought. Engine 2 (1965) and Engine 6 (1969) were almost identical FWD Tractioneer-Farrar pumpers, with 750-gallon-per-minute pumps, 1,000-gallon tanks, and foam systems. Engine 2 had a deck gun and was first due at the airport, while Engine 6 was in Hyannis Port. (Jack Grant collection.)

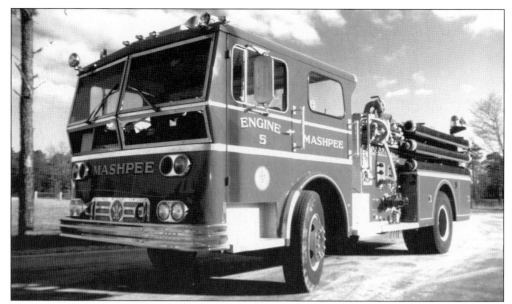

MASHPEE ENGINE 5 (255). The Mashpee Fire Department bought this Ward LaFrance 1,000-gallon-per-minute 500-gallon pumper in 1970. The cab of the Ward was very distinctive, and this was the only one of its kind ever to serve on the Cape. Engine 5 was refurbished in the 1980s, adding a fully enclosed cab and a new body to replace the rusty original cabinets. (Crosby photograph.)

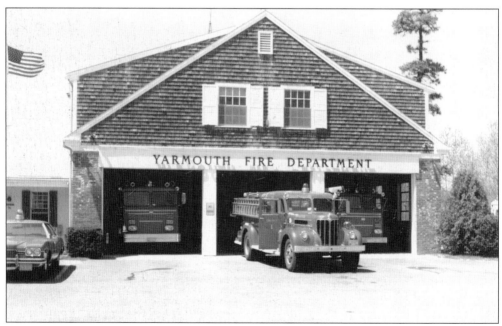

YARMOUTH HEADQUARTERS, SOUTH YARMOUTH. Another department that counted heavily on Maxim apparatus was Yarmouth. Three Maxim pumps ran out of Station 1 in South Yarmouth. The oldest, Engine 1, was made in 1950. The Maxim F cab-forward pumpers were Engines 3 and 5. The county mutual-aid center, KCD 246, was here from its beginning in the 1950s until 1991. This photograph was taken in the 1970s. (Yarmouth Fire Department collection.)

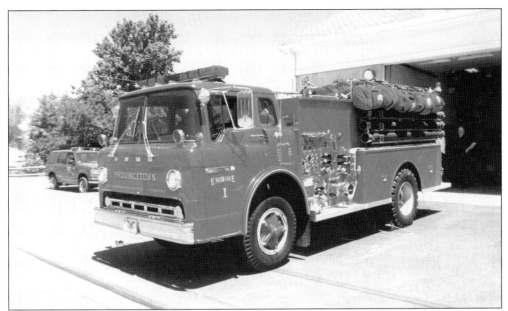

PROVINCETOWN ENGINE 1. Provincetown bought several short-wheel-base commercial pumpers built by Maxim in the 1960s and 1970s. Engine 2 (1962) and Engine 3 (1968) were both on Chevy chassis. Engine 1 (1973) was a 750-gallon-per-minute pumper built on a Ford chassis. It served in Provincetown until 2002. The compact style of Provincetown's engines is necessary to maneuver around town. (Crosby photograph.)

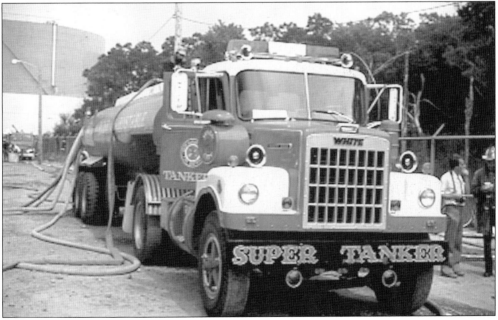

WEST BARNSTABLE'S SUPER TANKER. The village of West Barnstable does not have a water system. In an effort to protect the village better, this tractor-trailer 5,000-gallon tanker was built. It had a 1,000-gallon-per-minute rear pump and carried a folding tank. Truly one of the more "famous" trucks on the Cape, Tanker 296 was an important resource, responding to most big fires around the Cape in the 1970s and 1980s. (West Barnstable Fire Department collection.)

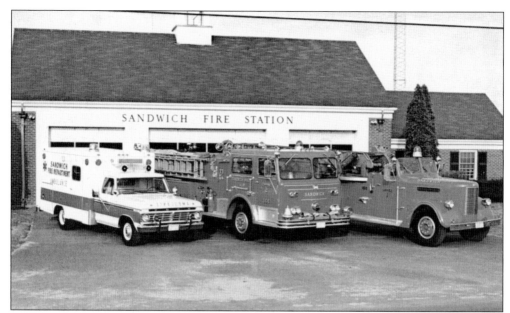

THE SANDWICH FIRE DEPARTMENT. The Sandwich headquarters was built in 1955 on Route 6A. Rescue 1 (145) was a 1975 Ford ambulance. Engine 2 (144) was a 1972 Maxim 1,000-gallon-per-minute pumper. Sandwich's first Ladder 1 (152), bought in 1974, was a 1953 Peter Pirsch 65-foot aerial that was originally the Boston Fire Department's Ladder 25. (Sandwich Fire Department collection.)

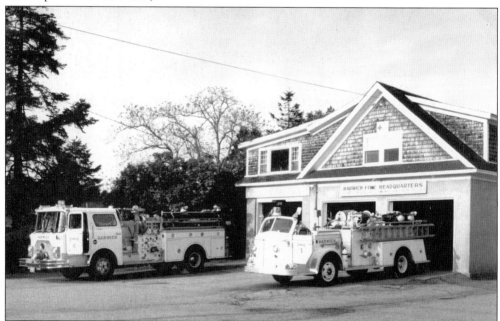

THE HARWICH FIRE DEPARTMENT. In many ways, the arrival of a new fire engine is a time of celebration. It demonstrates the advances and progress being made in firefighting. On the other hand, it also means saying good-bye to "old friends" whose loyalty and service have long been appreciated. The Harwich Fire Department's 1976 Mack Engine 4 and 1953 American LaFrance Engine 3 are seen together at the end of the day. (Harwich Fire Department collection.)

Nine

BEHIND THE SCENES

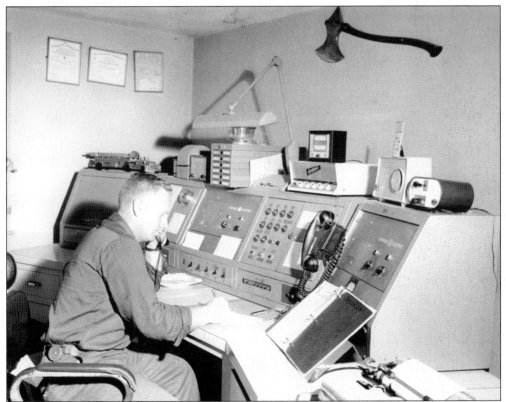

HARWICH FIRE ALARM. The public sees a small part of the fire department's world. They see the big fires and bad accidents in the news. The fire department operates 24 hours a day, however, and it is not all glamorous. Much of it is day-to-day answering phones, cleaning equipment, training, fire inspections, and a fair amount of horseplay. Bill Johnson is shown working a shift at KCD 271 in the 1960s. (Harwich Fire Department collection.)

THE SHACK. Located on the hill next to the jail in Barnstable village was a small shack that housed some of the first public safety radios on the Cape. Dating from the 1930s and operated by the Barnstable County Sheriff's Department, "the shack," as it came to be known, has assisted Cape fire and police department communications for decades. This photograph dates from the 1960s. (Barnstable Sheriffs Department.)

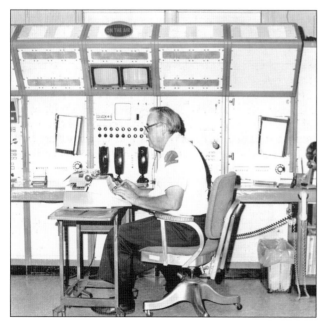

THE BARNSTABLE SHERIFF'S DEPARTMENT. Bill Whiteley was one of the dispatchers at the shack in the 1970s. The modern console was actually a hand-me-down from NASA that was used here in Barnstable County for years. As KCA 376, the shack handled police-related radio traffic. As KCB 781, it handled the fire-related traffic. In the mid-1970s, it also became home to KAG 416 as the emergency medical service CMED center. The sheriff's department continues to play a major role in Cape communications. (Barnstable Sheriff's Department.)

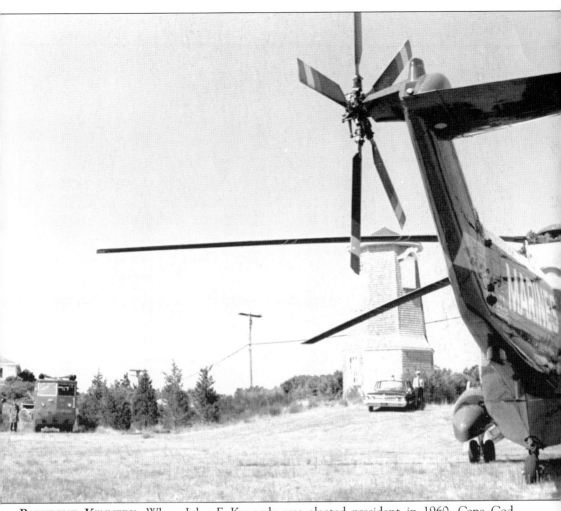

PRESIDENT KENNEDY. When John F. Kennedy was elected president in 1960, Cape Cod suddenly became the home of the president. He came here many times as president. Every time he did, the Hyannis and Otis Fire Departments were there behind the scenes. Whether he landed at Otis, Hyannis, or here on Squaw Island in Hyannis Port, it was the job of these fire departments to protect the president. In this view, Hyannis Chief Glenn Clough stands by his car as a Hyannis pumper and Otis O-11A crash truck stand by with the president's helicopter. A direct line from the White House was installed in the Hyannis and Otis stations. Both departments were on a moment's notice. An engine and ambulance even accompanied the president to church. (Hyannis Fire Department collection.)

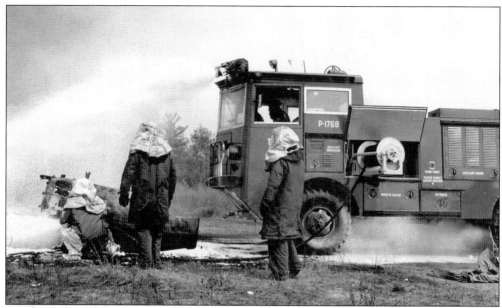

OTIS TRAINING. This 1952 American LaFrance O-10 crash truck was one of many apparatus to protect the busy airfield at Otis Air Force Base. The size and activity level of the base made it a center of research and development for the military. The fire department was no exception. Otis got to try a lot of "new stuff" first. Training with new foams, extinguishing agents, and apparatus made Otis firefighters very capable. (Calvin Hitchcock collection.)

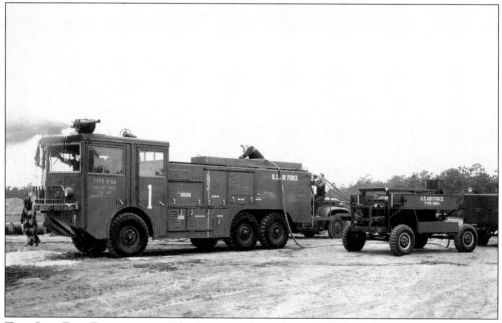

THE OTIS FIRE DEPARTMENT. The larger crash truck was called an O-11A. This 1953 truck carried 1,000 gallons of water, foam, and extinguishing agent. The O-11A is distinguished by its two roof-mounted foam turrets. Supporting the crash truck are the 1,000-gallon brush breaker and a foam trailer being tested for worthiness by the Otis firefighters. (Calvin Hitchcock collection.)

THE OTIS FIRE DEPARTMENT. The Otis Fire Department protected the largest air defense base in the world. Fire prevention was serious business, and Otis was good at it. In 1970, through a variety of successful programs with the military and civilian populations on the base, the fire department was recognized by the U.S. Air Defense Command as being the best in the world for its fire-prevention program. (Calvin Hitchcock collection.)

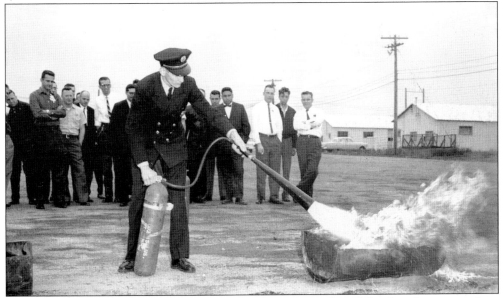

THE OTIS FIRE DEPARTMENT. Calvin Hitchcock was a member of the Otis department from 1954 to 1982. While in fire prevention, one of the duties of Hitchcock as crew chief was to train base personnel and contractors in fire safety. Here, he demonstrates a carbon dioxide fire extinguisher on a small flammable liquid fire. Hitchcock went on to serve as chief of the department from 1972 to 1982. (Calvin Hitchcock collection.)

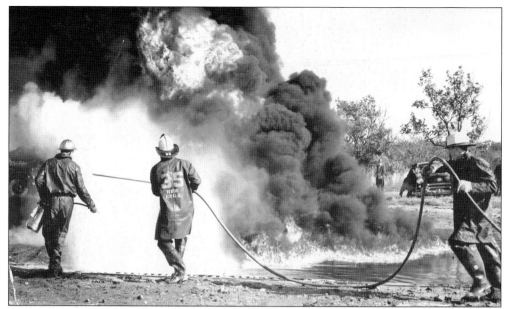

HARWICH TRAINING. Flammable liquid fires were always a concern of firefighters. Gasoline could ignite quickly, with devastating consequences. In the 1950s, 1960s, and 1970s, a lot of training was conducted by firefighters on the use of water, foam, and extinguishing agents on these fires. Without formal training facilities, training was sometimes done in sandpits or fields. This photograph dates from the 1960s. (Harwich Fire Department collection.)

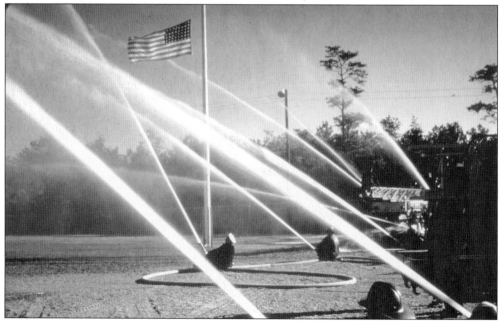

THE BARNSTABLE FIRE ACADEMY OPENING. After years of work, the Barnstable County Fire Chiefs finally opened the new Barnstable County Fire Academy, behind the airport off Mary Dunn Road in Hyannis. Firemen from all over the Cape have attended "fire school" here. A massive display of hose streams and equipment christened the new facility during Fire Prevention Week in October 1959. (Crosby collection.)

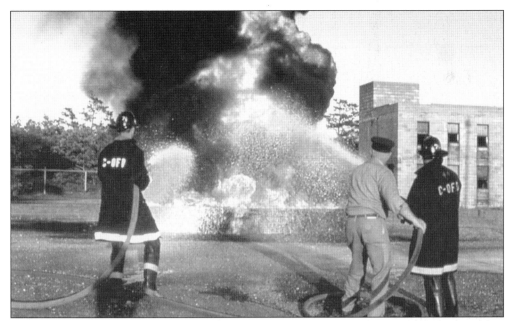

BARNSTABLE FIRE ACADEMY. The new fire school was on seven acres of land. It had a classroom facility shipped in from Otis, a two-story block smoke house, a large drill yard, and several cement pits in various shapes that were used for flammable liquids fire training. "Pit fires" were hot and a challenge for firefighters to extinguish. The real-life experience of this training was invaluable. (Centerville-Osterville-Marstons Mills Fire Department collection.)

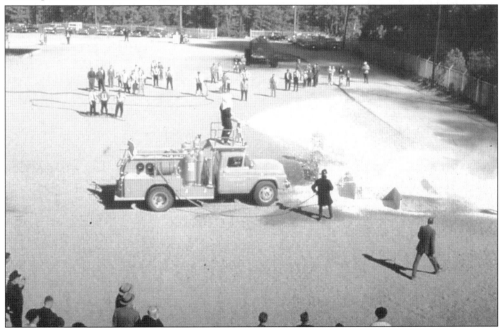

FIRE ACADEMY DEMONSTRATION. Public relations is an important part of the fire department. When the new fire school opened, the public was welcome to watch demonstrations, look at the apparatus, and meet the firemen. The Barnstable crash truck demonstrates its foam knockdown power on the "zigzag" pit in 1959. (Crosby collection.)

123

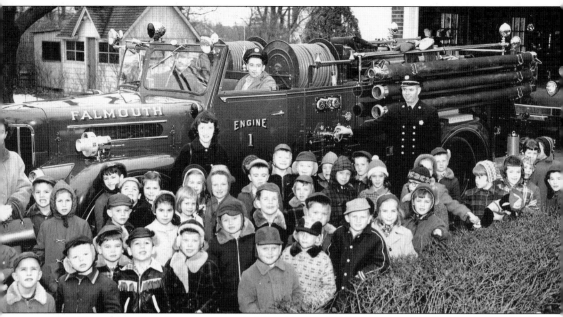

THE FALMOUTH FIRE DEPARTMENT. Falmouth's new 1956 Maxim pumper Engine 1 was a big hit with this group of kids from the local school. Fire Prevention Week in October has traditionally been a great reason to bring the kids to the fire station. It gives them a chance to meet the firemen and gives the firemen a change to teach them a little about being safe with fire. Sometimes it also plants the seeds that turn into future firefighters. (Falmouth Fire Department collection.)

SANTA ARRIVES, EASTHAM. The arrival of Santa in Eastham was a big hit with kids, as seen in this 1960s view. Eastham's 1956 Ford-Farrar Engine 3 served as the big man's red sleigh. It had a 600-gallon-per-minute pump and 1,000-gallon tank. Santa has always been a good friend of the fire department and still makes visits each year. (Eastham Fire Department collection.)

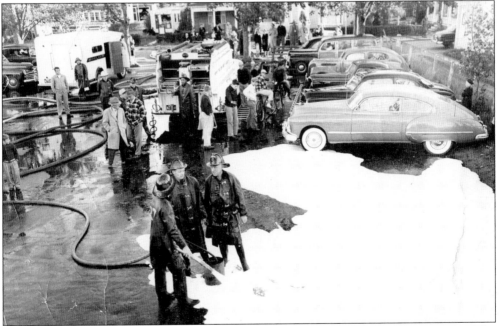

FIRE DRILL, HARWICH. Harwich firefighters apply foam in a parking lot in the 1950s. The snowlike foam is quite slippery. Fire drills like this were held regularly and were often observed by the public. The curiosity of the public gave firefighters an opportunity to show off their equipment and answer questions. The Harwich ladder truck and rescue truck are in the parking lot. (Harwich Fire Department collection.)

125

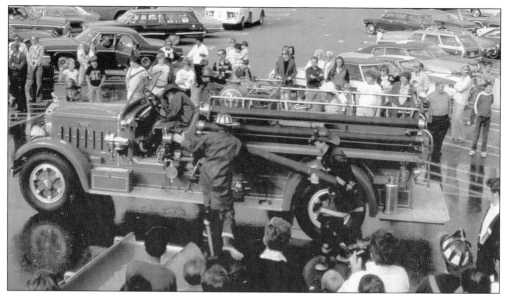

THE FIREFIGHTERS' MUSTER. During the 1970s and 1980s, firefighters from across the Cape participated in an annual firefighters' muster. The muster was held in Hyannis during Fire Prevention Week. Teams from many of the departments competed in various events that demonstrated the speed and skills of its members. Here, Barnstable's 1935 Mack is preparing to draft from a portable tank. These musters were a great deal of fun and were well attended. (Crosby collection.)

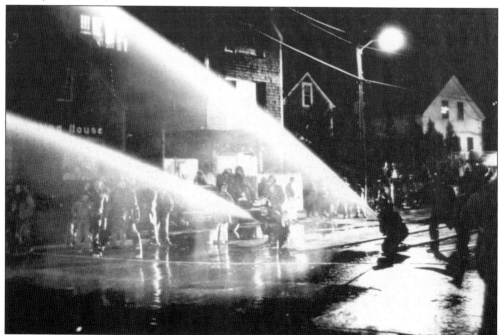

PROVINCETOWN MUSTER. The competition between Provincetown's engine companies was also demonstrated in an annual muster in Provincetown. In this 1970s photograph, members compete to move an overhead target in a hose event. These events are great fun for the firefighters, their families, and the public. (Provincetown Fire Department collection.)

EVERYONE WANTS TO BE A FIREMAN. Dennis fire chief Edward Clough pins an honorary firefighter badge on Vaudeville comedian Joe E. Brown in 1939. Brown was performing at the Dennis Playhouse when he visited Dennis firefighters. It seems as if everyone wants to be a fireman at one time or another, and this was no doubt a special moment for Brown. (Dennis Fire Department collection.)

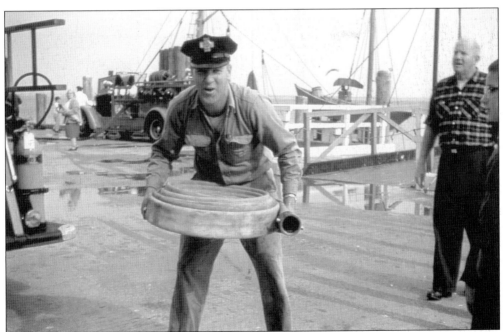

WHEN THE FIRE IS OUT. A Truro firefighter holds a roll of "two and a half" in this 1960s photograph. A lot of work goes into putting out a fire. A lot of work also goes into preparing for the next one. Hoses must be rolled, trucks refueled, water tanks refilled, air bottles topped off, and equipment cleaned. There are meetings and drills to attend. There are all sorts of problems to be solved. In the end, however, it is a job well done. (John W. Garran Sr. collection.)

A Leap of Faith, Harwich. In this 1960s photograph, Harwich firefighter Bill Johnson demonstrates his faith in his fellow firefighters by leaping into a life net. Not everyone joins the fire department. For those who do take the leap, it is often on the recommendation of friends. Sometimes, that small step turns into a lifelong rewarding career experience. Young firefighter Robert Peterson (right with white socks) went on to have a long successful career as a Harwich firefighter and officer, achieving the rank of chief of department in 1993. (Harwich Fire Department collection.)